Cambria
A Modern Camelot

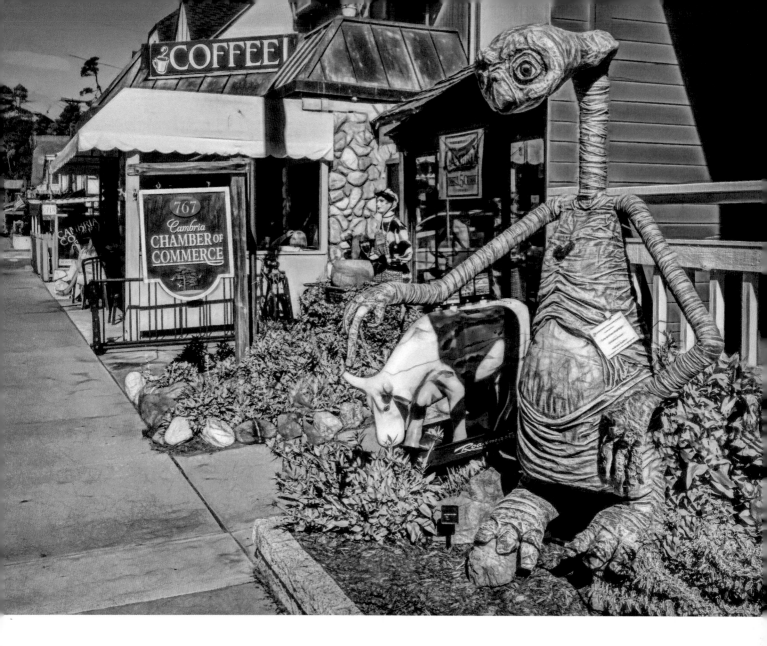

Cambria, A Modern Camelot ISBN-10: 1543160611

Written and photographed by Elisabeth Haug
BISAC: Travel / United States / West / Pacific
Copyright Elisabeth Haug 2017
Published by Pathfinder Publications,
Visit http://EHaug.com and http://ElisabethHaug.com
contact: info@ehaug.com

There is something about Cambria—a unique magic!

Is it the amazing nature? The sound and smell of the ocean? The abundant wild life? The invigorating, ancient, volcanic energy? The pleasant, yet refreshing, climate? The vibrant colors and the mesmerizing light? Or is it the contented people and the whimsical atmosphere?

It is undoubtedly a combination of all of the above that creates Cambria's allure. Our little town is located on the Central California Coast adjacent to Highway 1. We are at the southern tip of the Big Sur Coastline and our vistas represent that icons' gentler side.

We have the mountains, forests, ragged coast lines, waves, and views that Big Sur is famous for. But we have them in a moderation that makes our nature feel more intimate to most.

In addition to all of the above, we have long, sandy beaches, dunes, and vast areas of open range land. And—best of all—our roads are flat, straight, and without traffic build up.

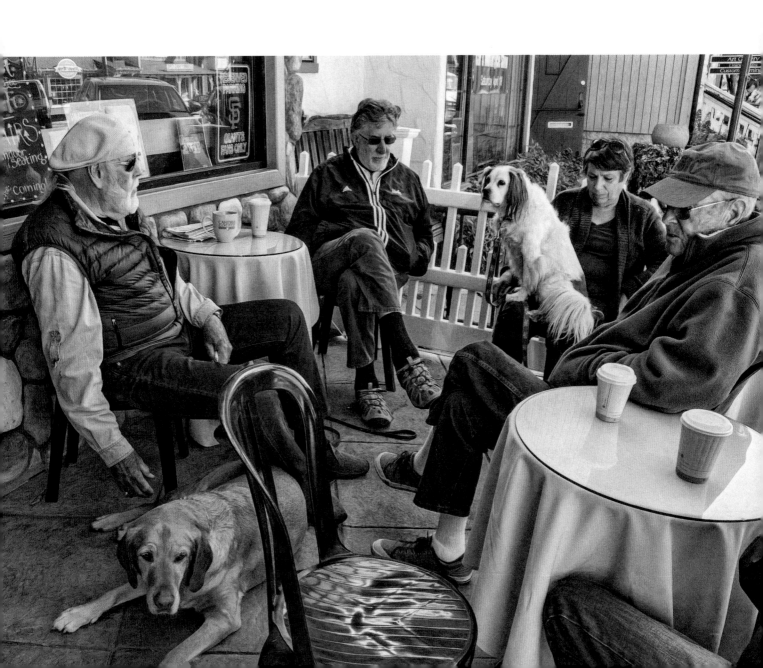

Cambria is a small town with pizazz. There is something here for everyone. And you can count on being entertained, touched, and amused. Here, it is safe to expect the unexpected.

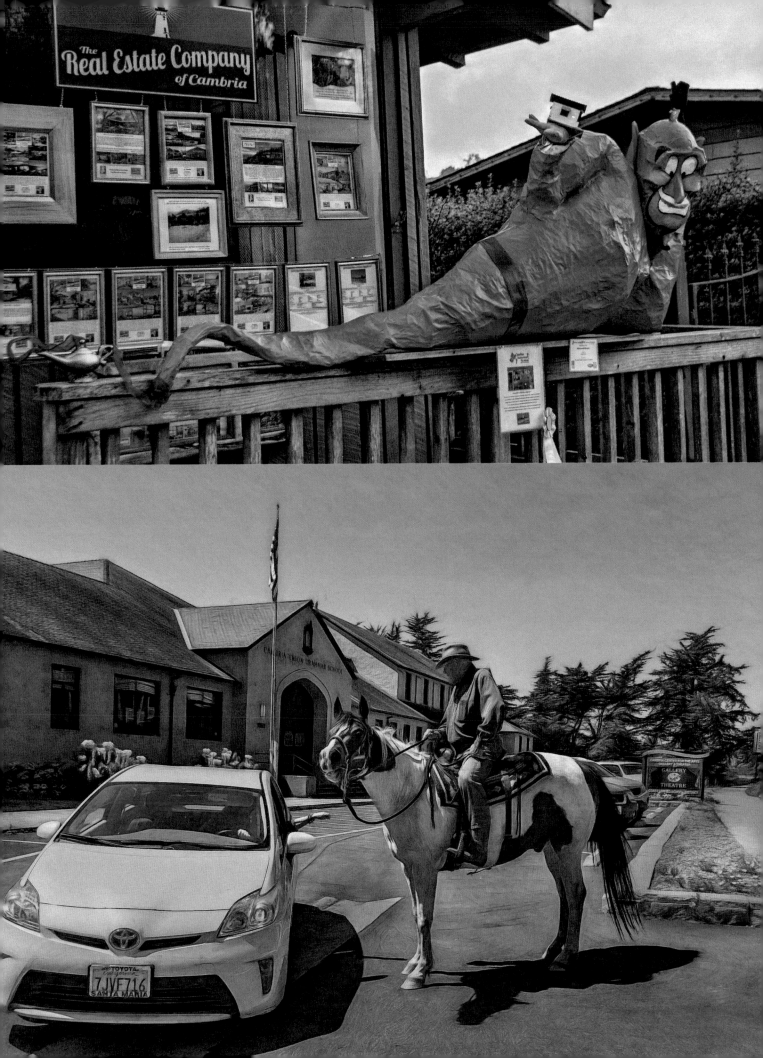

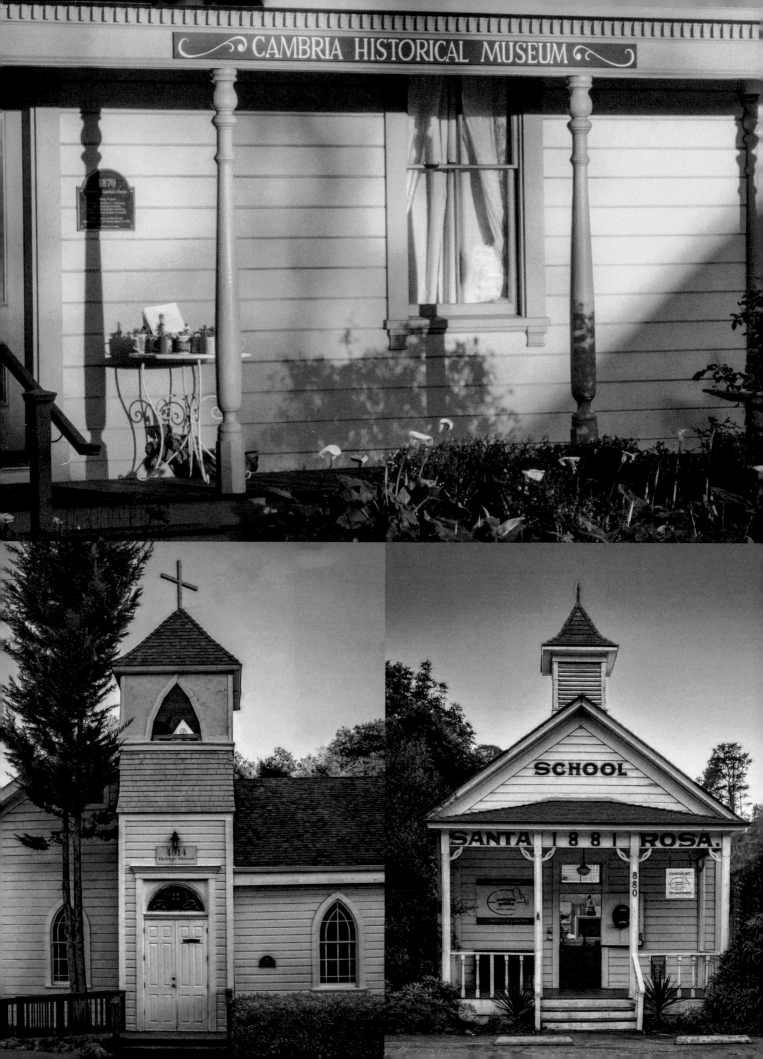

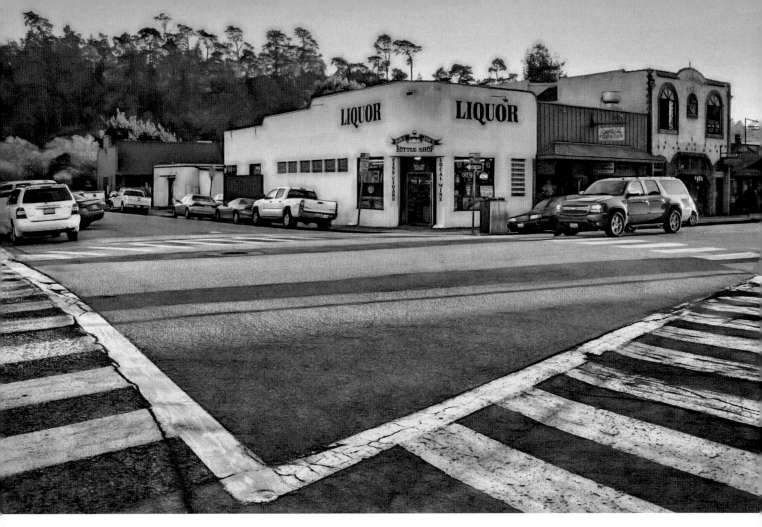

Throughout the ages, Cambria has been a popular place. About 30,000 Native Americans of the gentle, generous, peaceful Chumash tribe used to live here. They came almost a millennium before the Spanish who made their way here in 1769.

Fresh water, grassy range lands, and abundant lumber was a draw for early settlers. Mercury was discovered in 1867 and for a short while Cambria became a mining boom town. In 1869 a major fire razed most of downtown Cambria. None the less we still have a few old buildings. The old Santa Rosa Chapel, The Santa Rosa School, and the Historical Museum are among the most prominent.

In the early nineteen hundreds Cambria was discovered as a vacation town. Central Valley residents fled their local high temperatures to holiday on the beach. Tourists became aware of the area after Highway one was finished. Now it is wise to book lodging well in advance.

For a small town, Cambria has an abundance of businesses. The majority are geared towards visitors, of course, but their merchandise and services are fun and inventive as well as more attractive and of a higher quality than what is common in most tourist towns.

RARE AND UNUSUAL SUCCULENTS grow

ANTIQUES

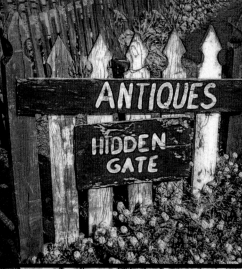
ANTIQUES HIDDEN GATE

HOME IS WHERE THE *Wine* IS

Antiques

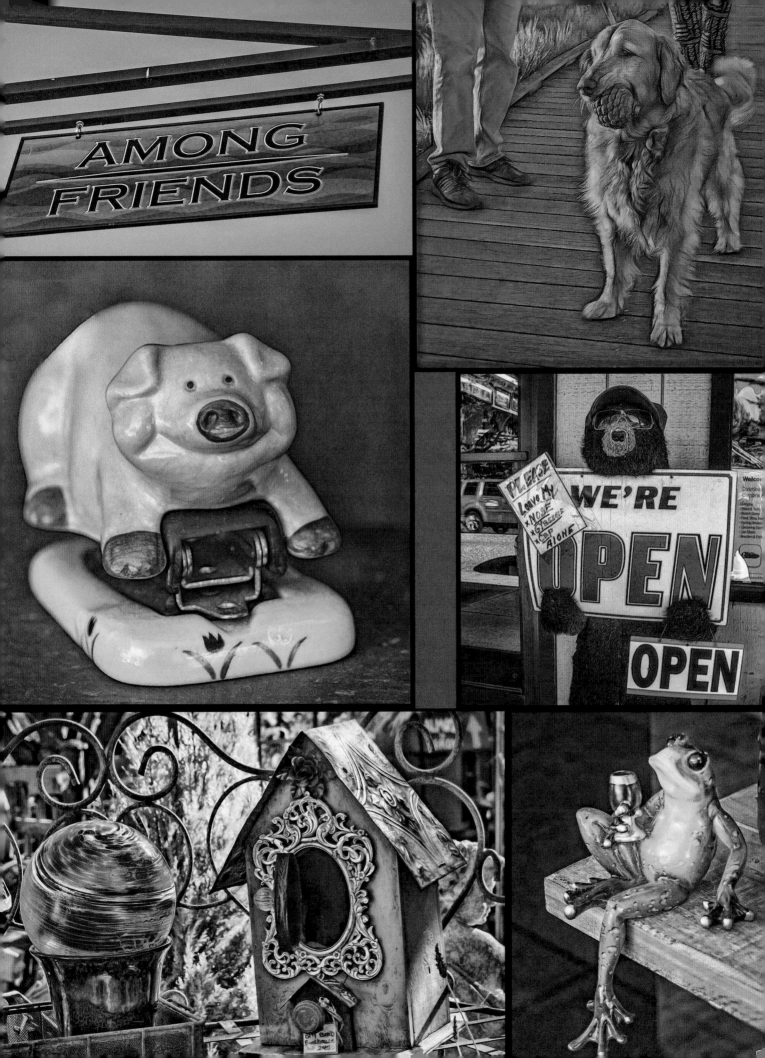

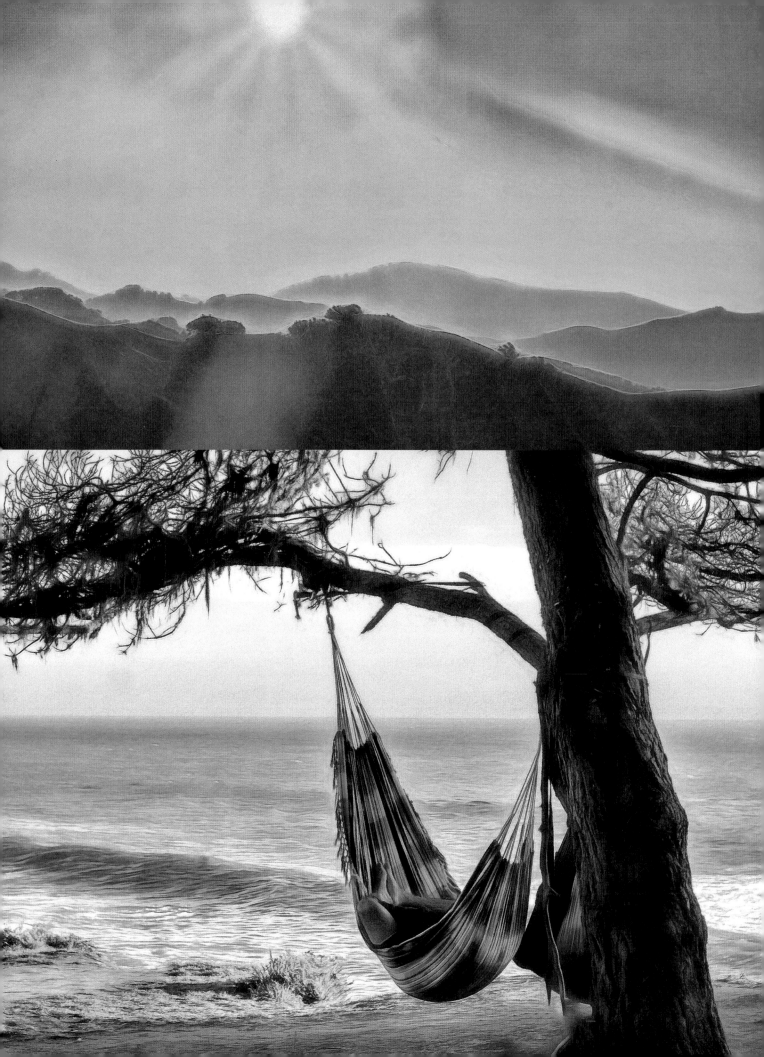

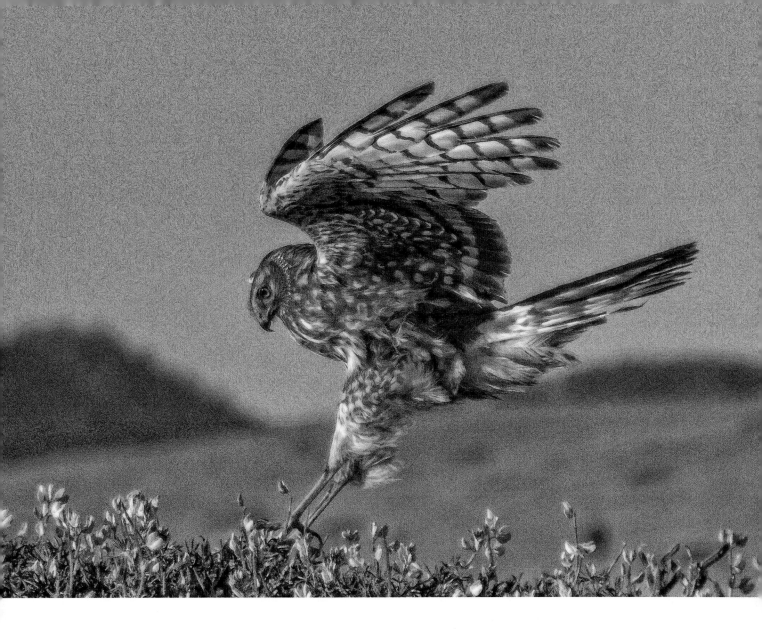

We Cambrians love our many excited tourists. Not just because of the revenue they bring us, but also because they treasure and enjoy our town as much as we do. Their appreciation constantly reminds us of just how fortunate we are to live here.

Cambrians are creative, whimsical, and zany. They are also fun loving, friendly, and helpful. They are natural volunteers in every field from being docents to driving the community bus and building boardwalks.

When hiking the trails be aware that it is proper etiquette to greet everyone you meet and to perhaps exchange a few words. Not doing so is considered rude.

Cambria is a calm and quiet place, yet there is always some exciting action for those looking for a bit of fun and adventure. Our festivals are a part of who we are.

We are simultaneously home spun and sophisticated. We thrive on fun and like to gather and socialize. We are slow paced but we get things done.

There is good reason for people—once they have discovered our modern Camelot— to return to us time and time again.

Contact with nature is a balm for the human soul. Indisputably, we all need to recharge our batteries regularly—to get away from the rat race and back into a simple world.

The sunshine on our faces, the wind in our hair, and the sound of the ocean washes the cobwebs from our minds. If you add serenity, stunning views, plants, birds, animals, and even a birthing Elephant seal to the equation you will know you have found a definite rejuvenation winner.

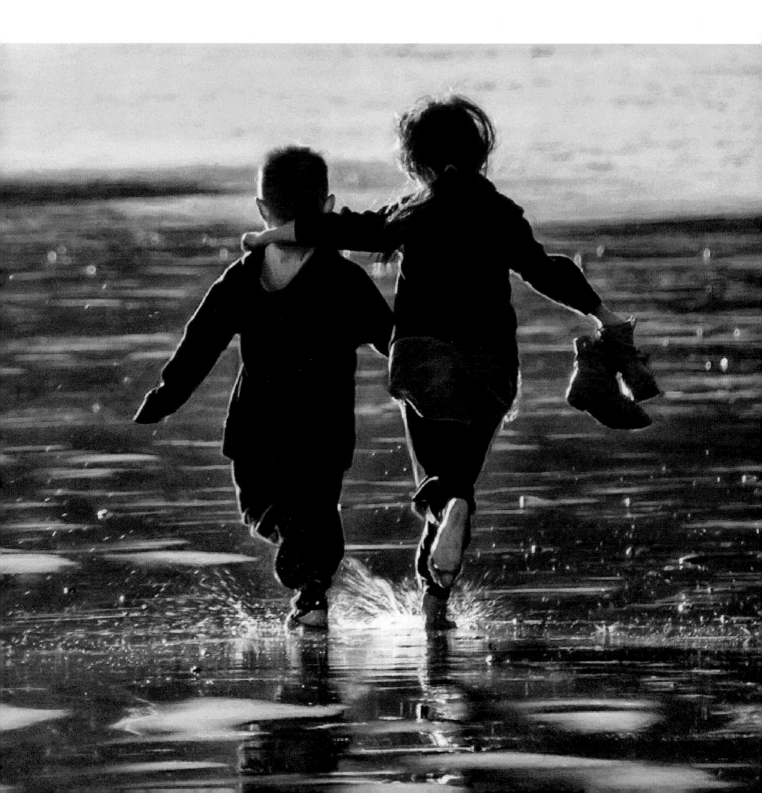

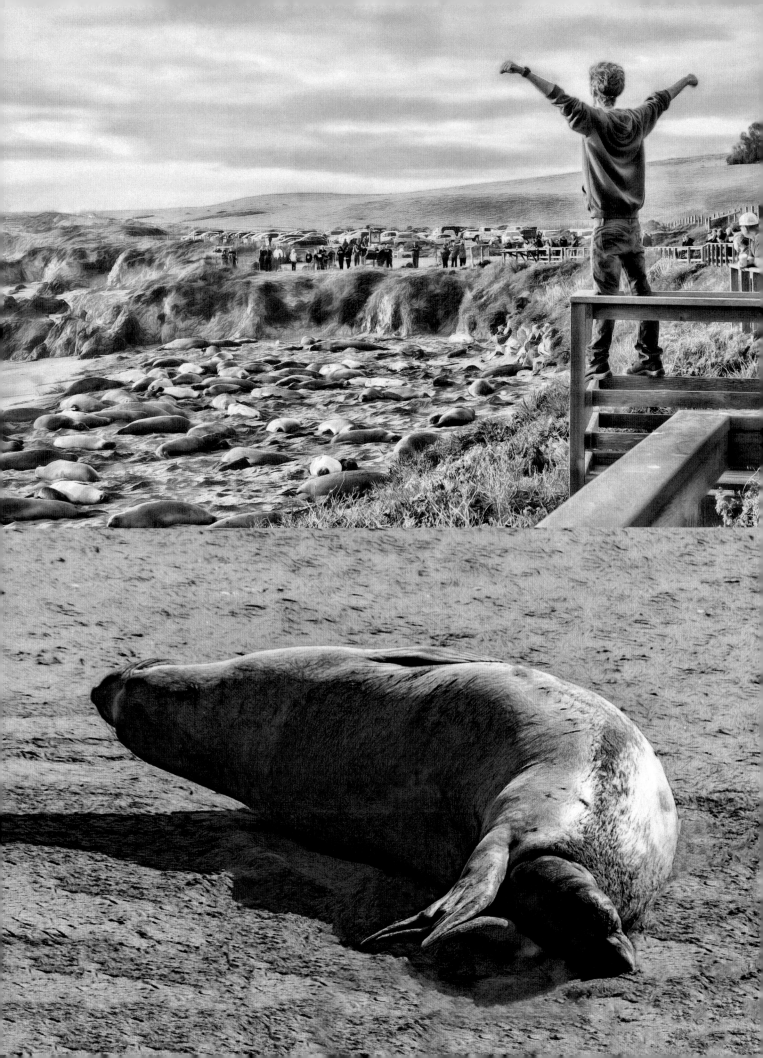

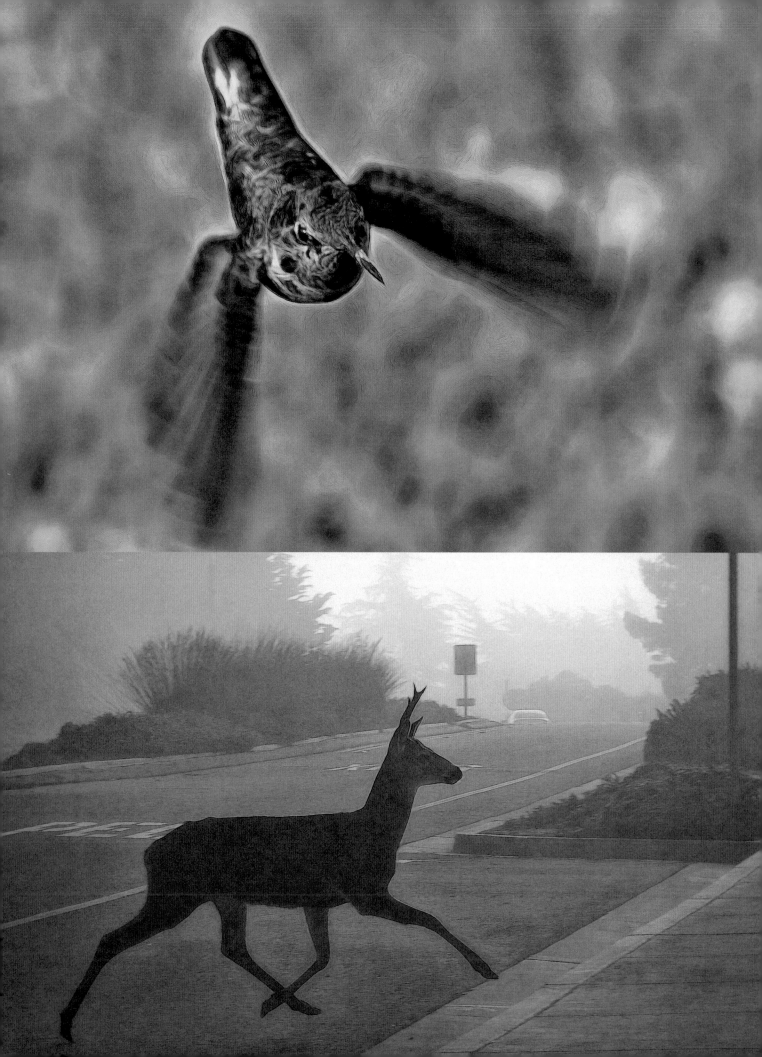

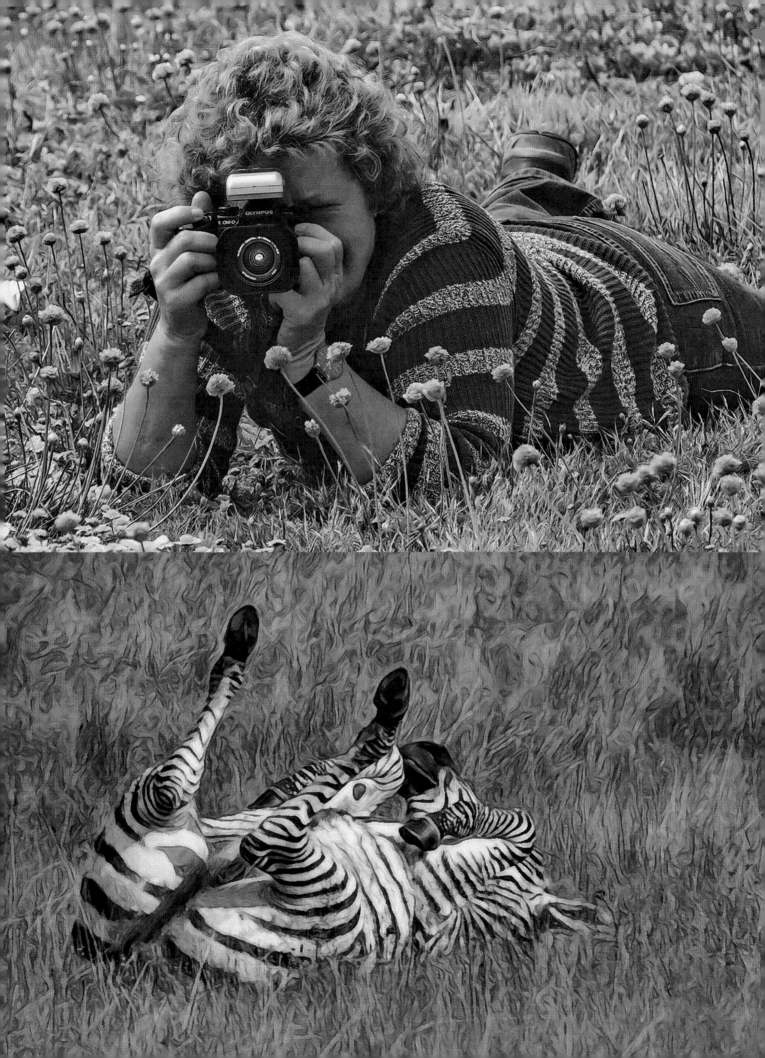

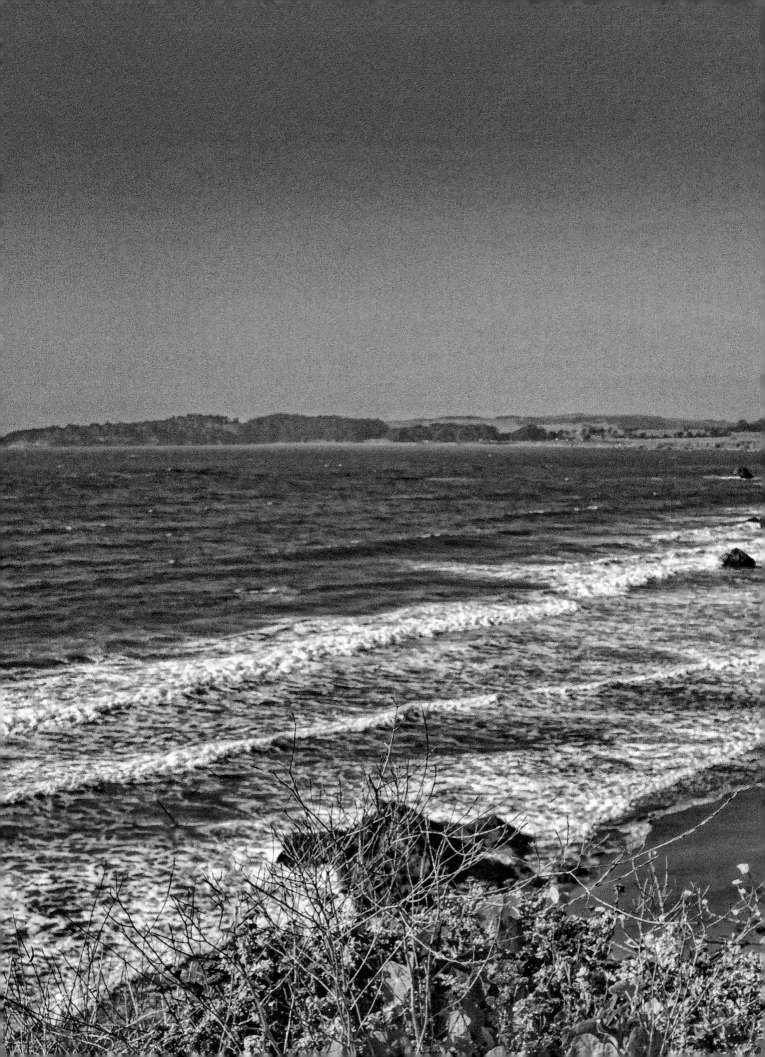

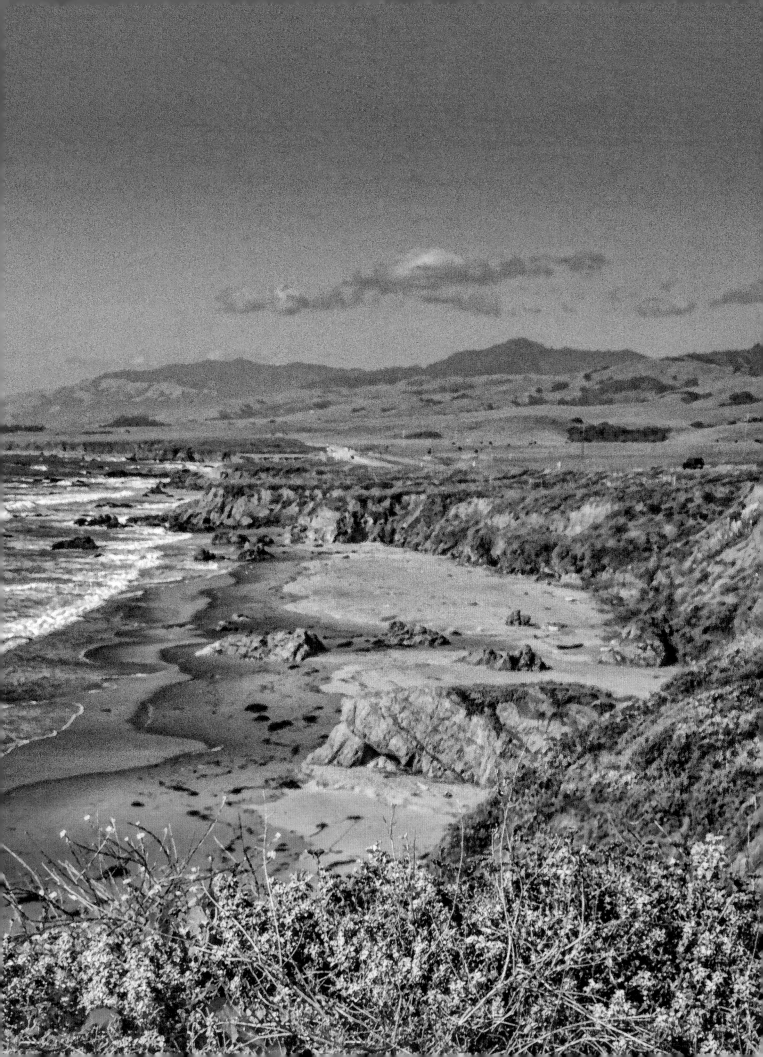

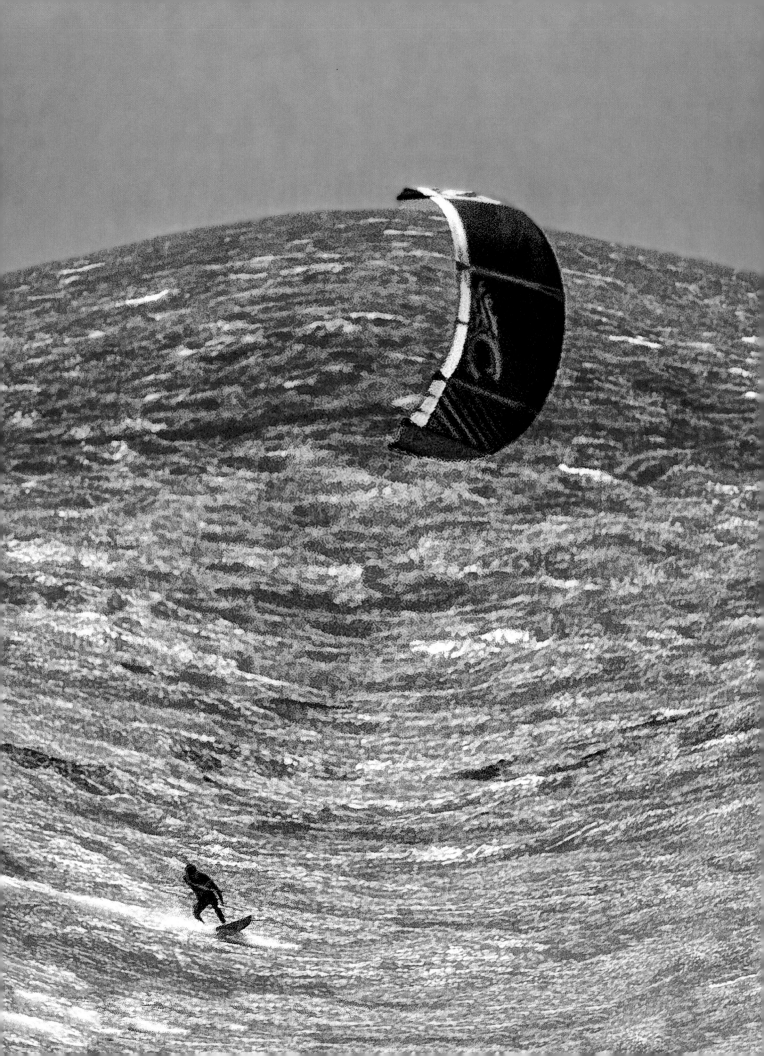

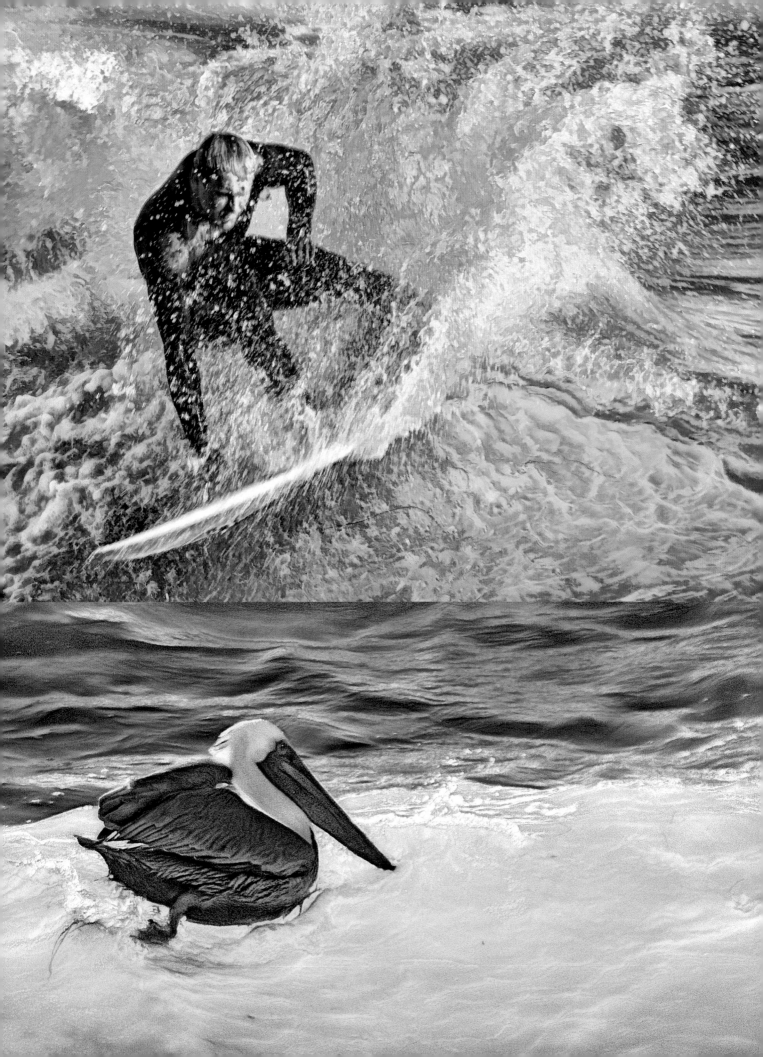

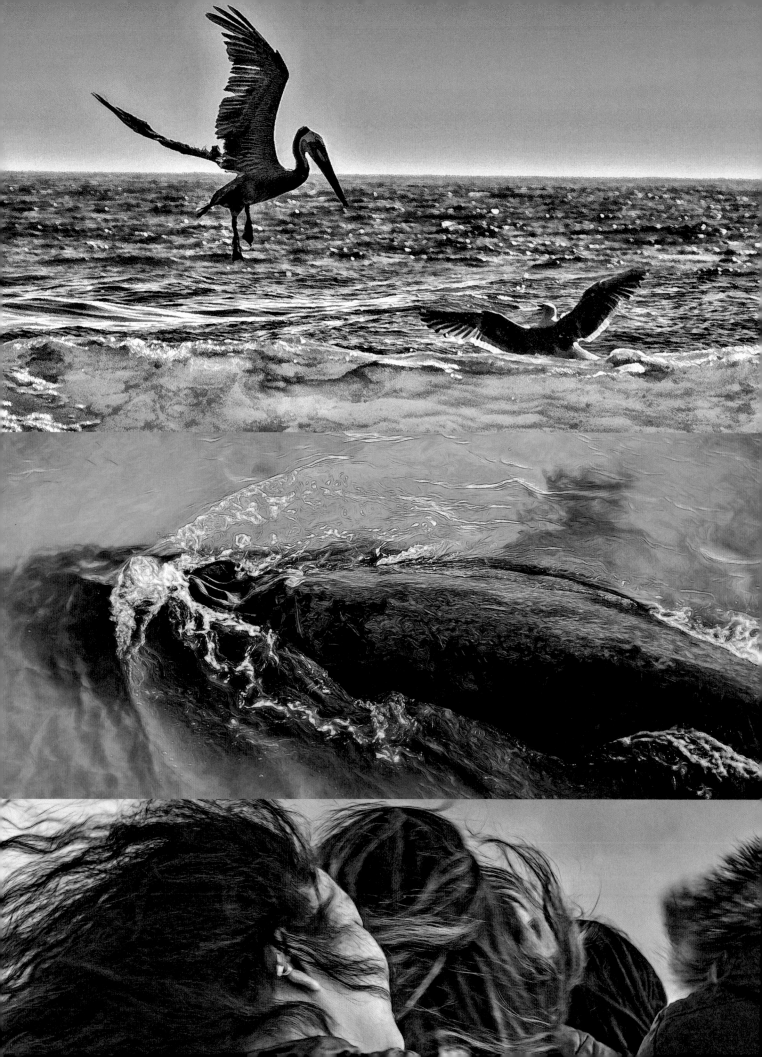

Fourth of July and Shamel Park:

Shamel Park is Cambria's community park. With access to the wide, sandy stretches of Moonstone Beach it is popular with everyone.

There is always fun to be had here. As well as BBQ pits and large grassy areas where dogs, children and adults play, the park has a swimming pool and a large well equipped playground.

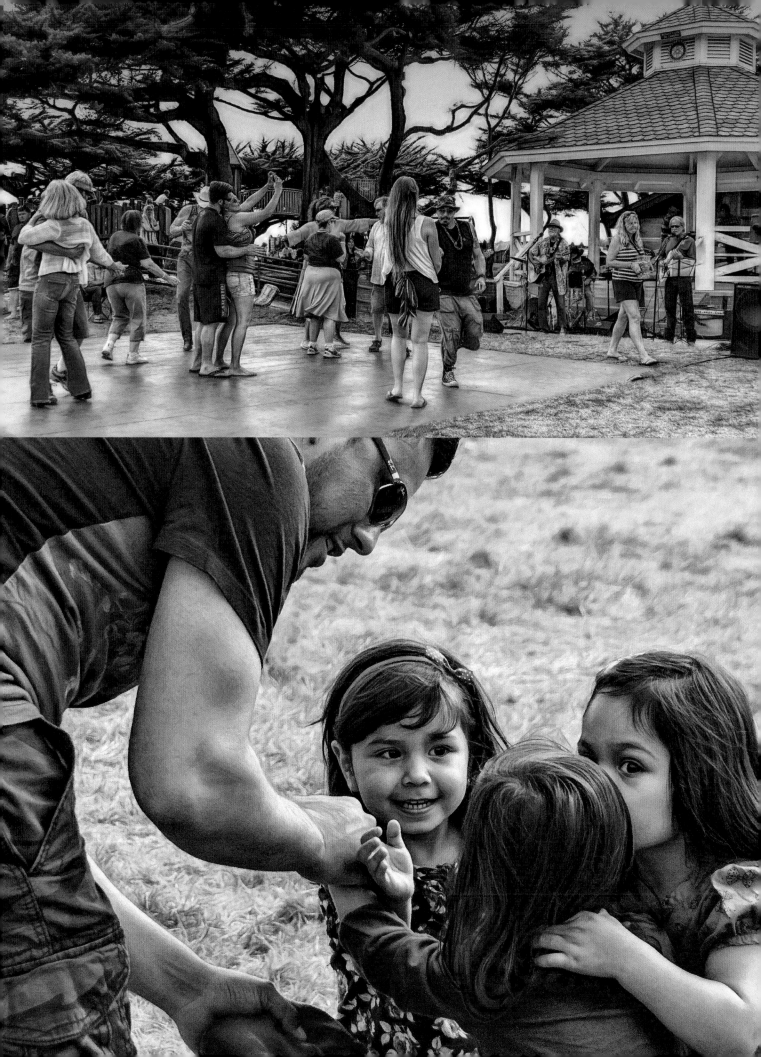

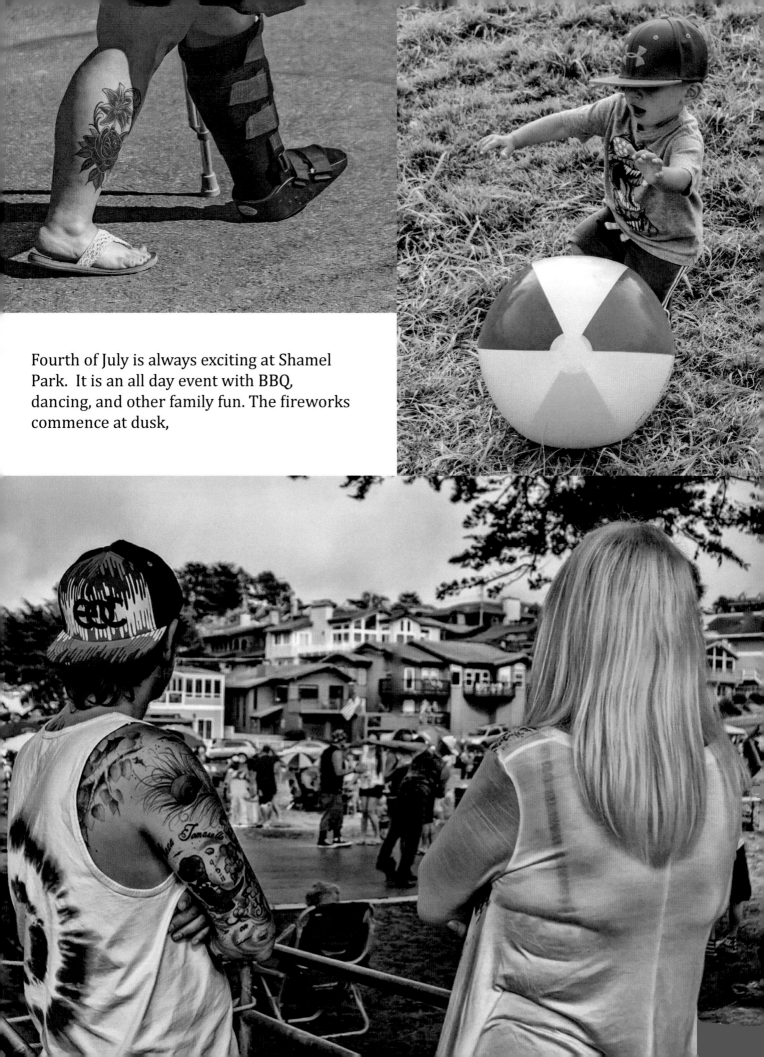

Fourth of July is always exciting at Shamel Park. It is an all day event with BBQ, dancing, and other family fun. The fireworks commence at dusk,

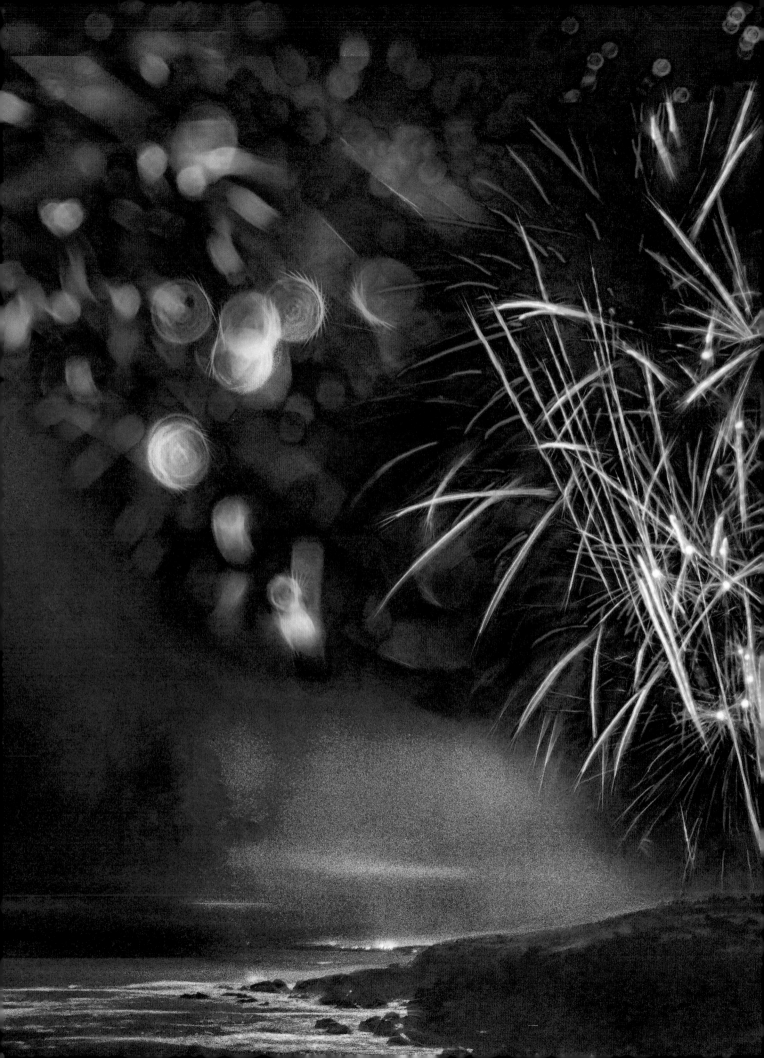

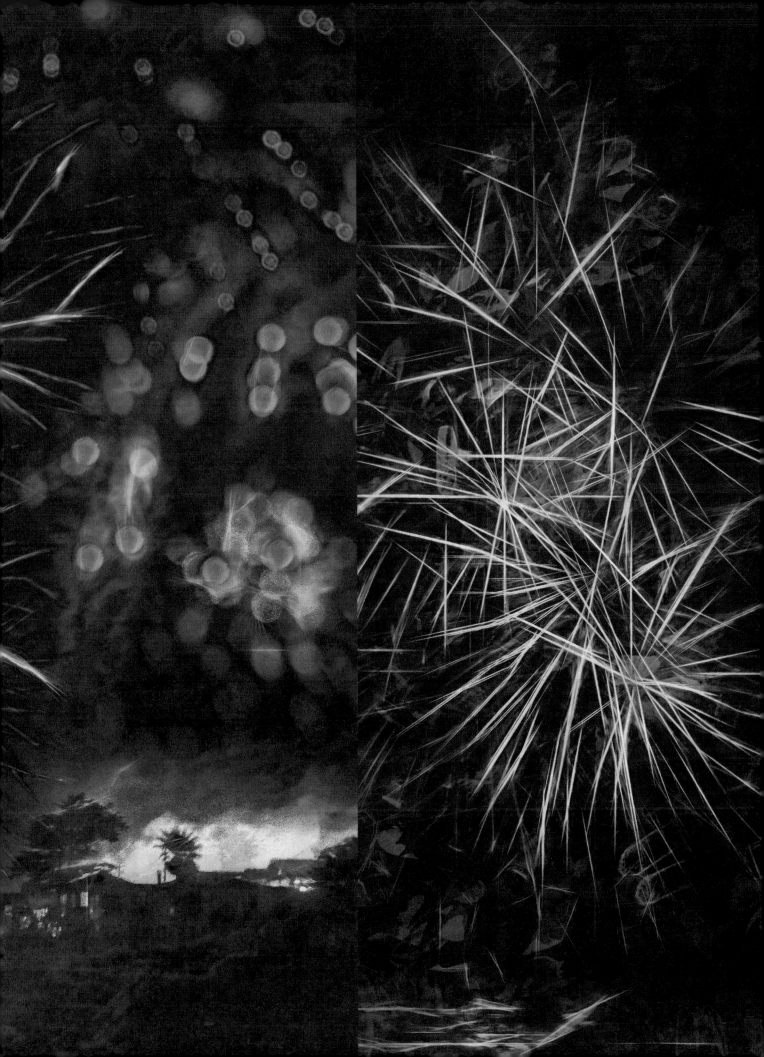

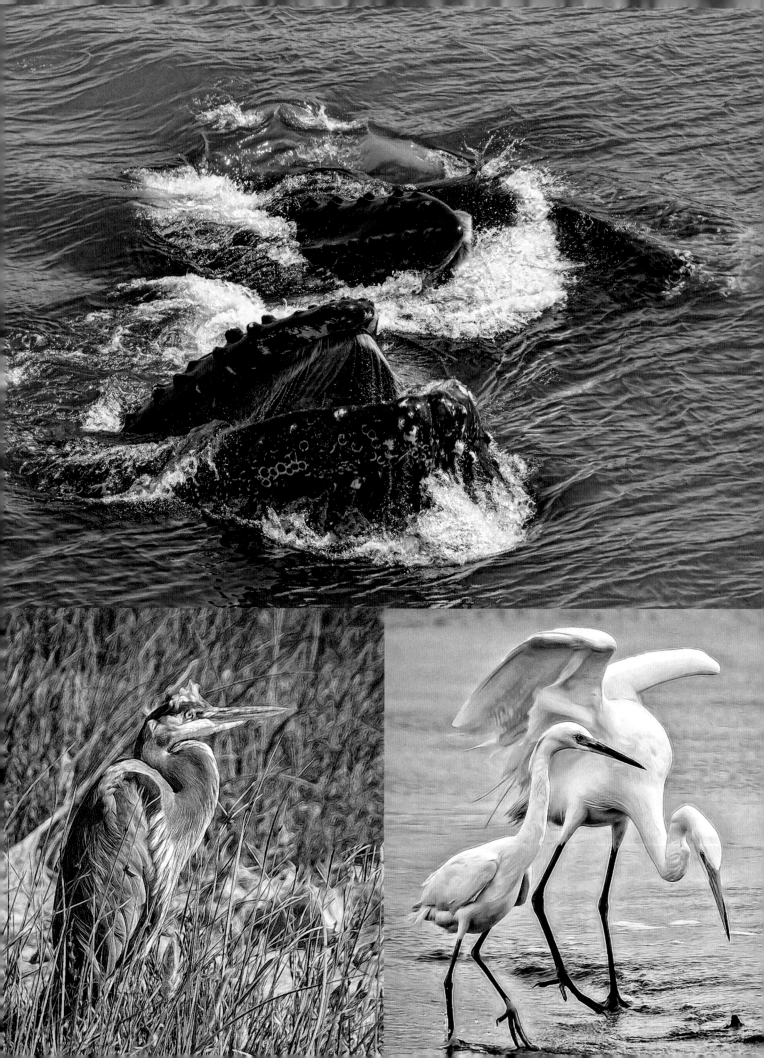

Wild Life:

The Cambria area is well-known for its many fish, birds, deer, elk, and assorted marine mammals. One reason we have so much is that we are on the migration route of a variety of species.

Fishing is popular all along the coast—from land, piers, and kayaks.

Whales— gray whales and humpbacks— travel along our coastline almost yearlong.

Monarch Butterflies cluster and winter in San Simeon State Park, in Morro Bay, and at Pismo Beach.

Northern Elephant seals have made the Piedras Blancas Coast one of their only beach homes.

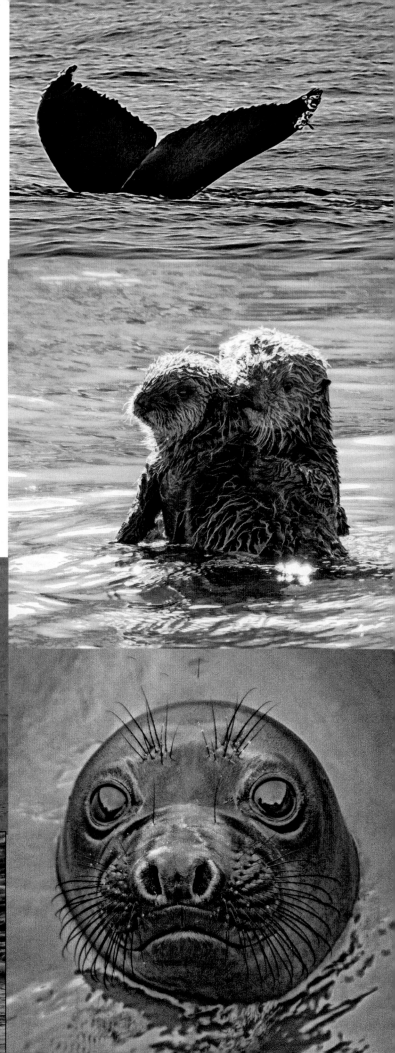

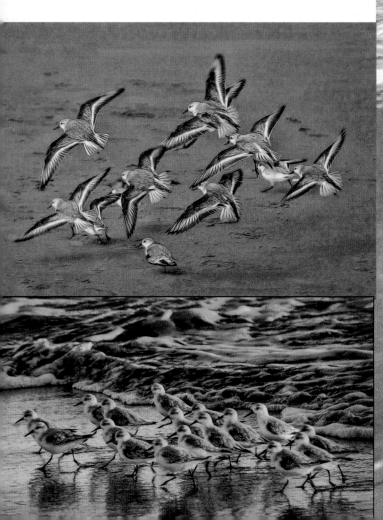

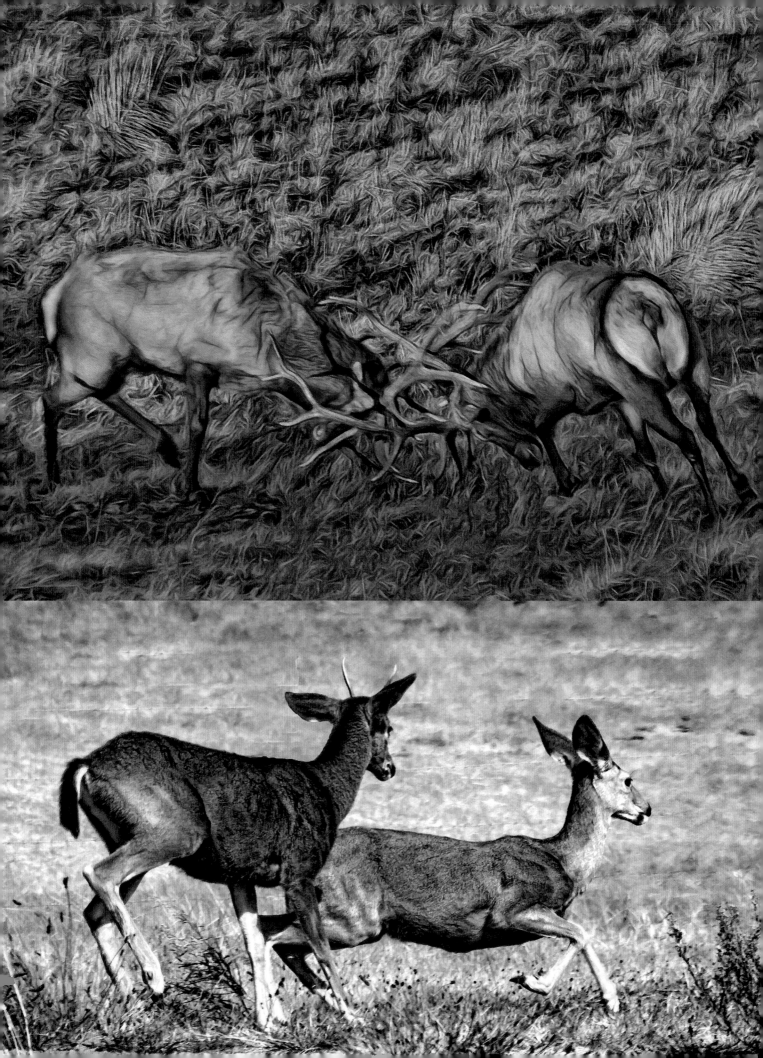

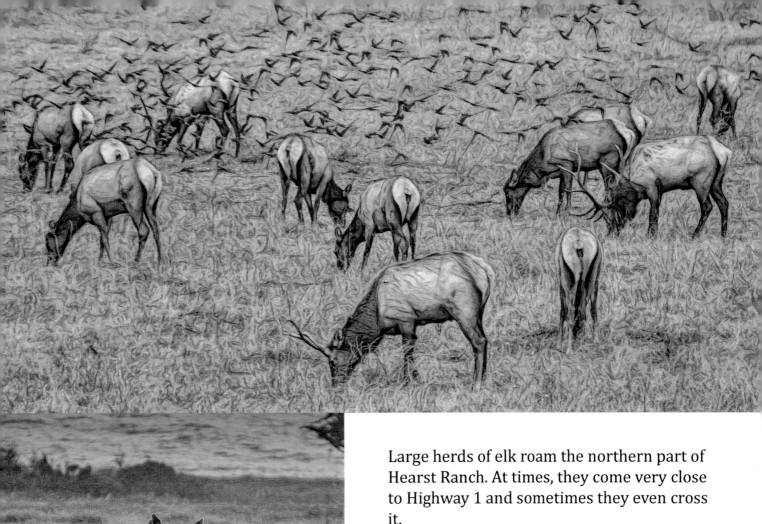

Large herds of elk roam the northern part of Hearst Ranch. At times, they come very close to Highway 1 and sometimes they even cross it.

Deer are a favorite in Cambria. As you cruise the wooded and residential areas you are almost certain to see a number of them on the street and in people's gardens. Be careful as you drive. They have little fear of people and traffic. Just like other pedestrians they expect you to brake for them.

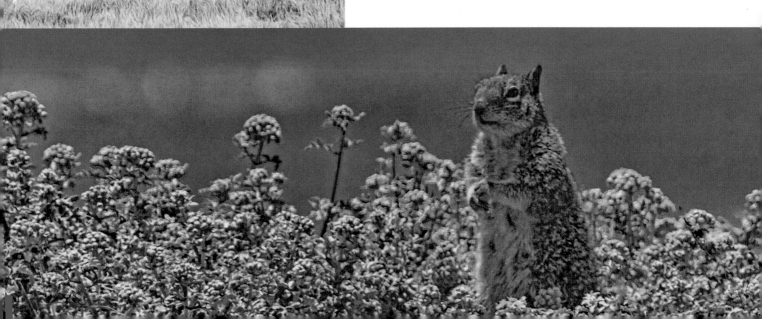

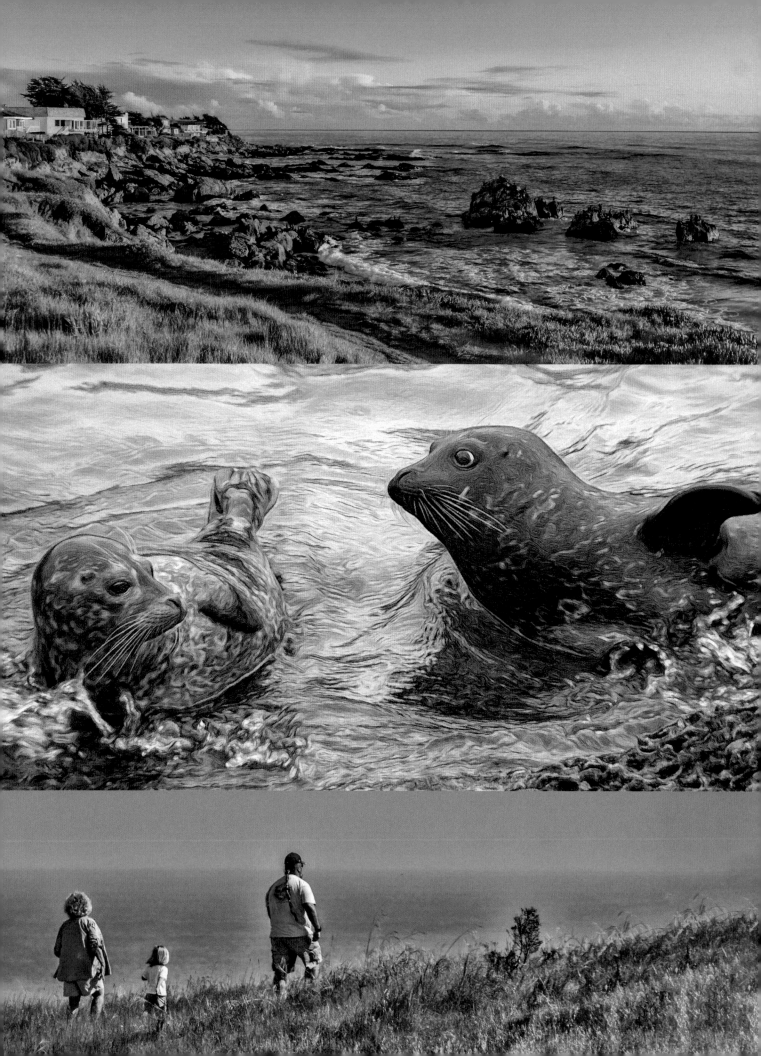

Fiscalini Ranch:

Fiscalini Ranch Preserve is one of Cambria's treasures. It has 430 of wonderful acres of oceanfront, range land, and Monterey pine forest. The "Ranch" has a network of trails and with its many zany benches it great place to hike for nature lovers of all fitness levels.

In early times, the preserve was inhabited by Chumash and Salinas tribes. Later it became a cattle ranch. In the 1980s it fell into the hands of developers. Luckily it was rescued in 2000 when various preservation organizations purchased it for $11.1 million.

Walking on Fiscalini Ranch is never boring. Wildlife is abundant with numerous birds, harbor seals basking on the rocks, migrating whales passing by, sea otters, rabbits, squirrels, deer, foxes, bob cats, and much more.

Fiscalini Ranch is also the home of a wide variety of plants and trees—rare and common.

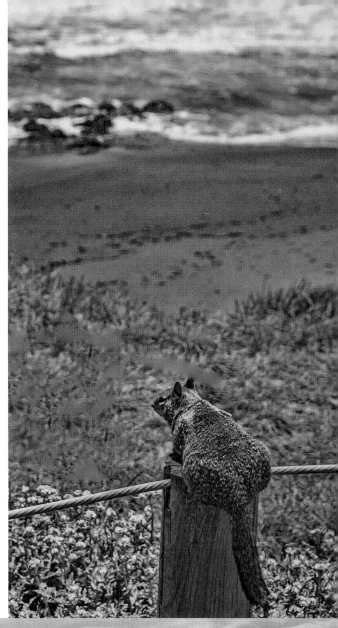

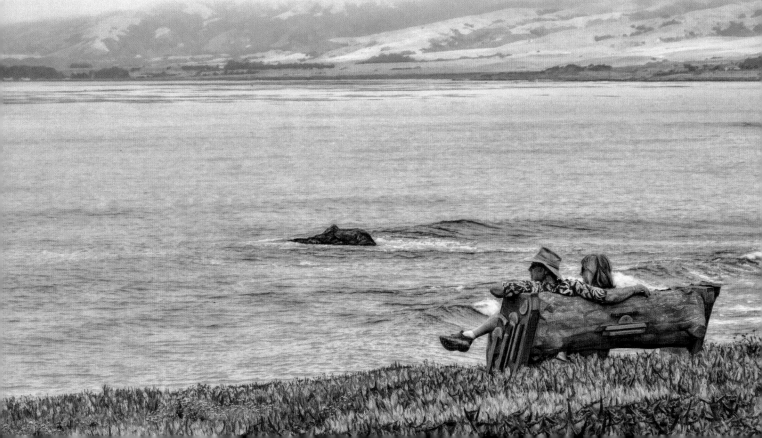

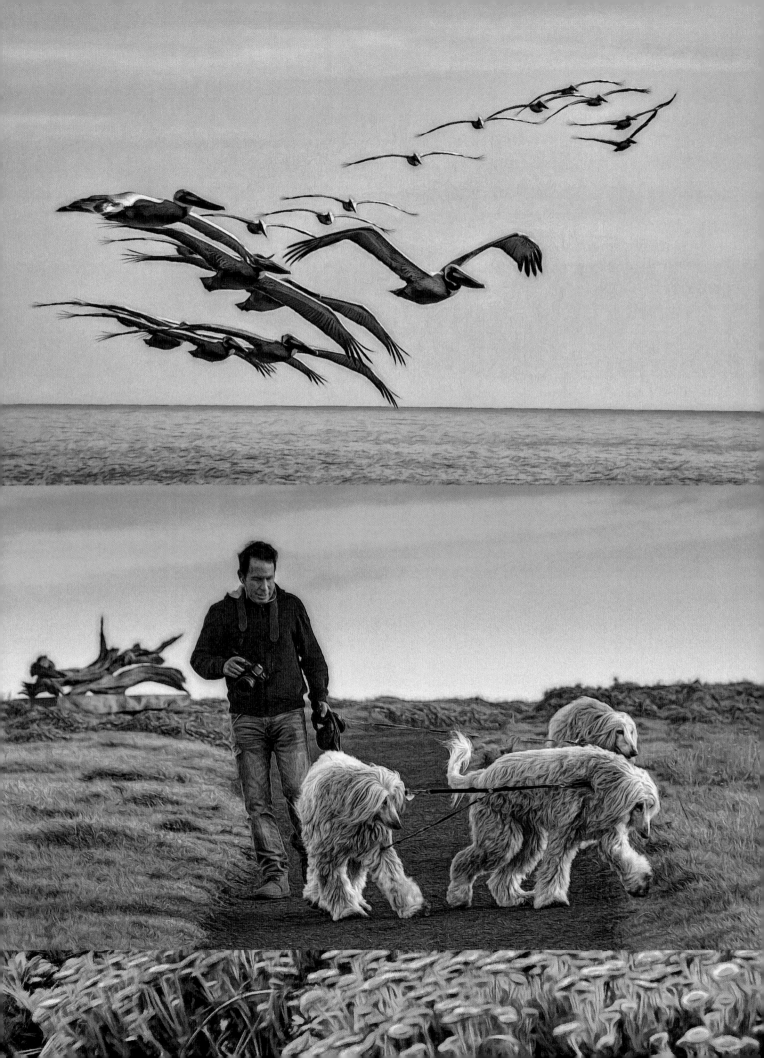

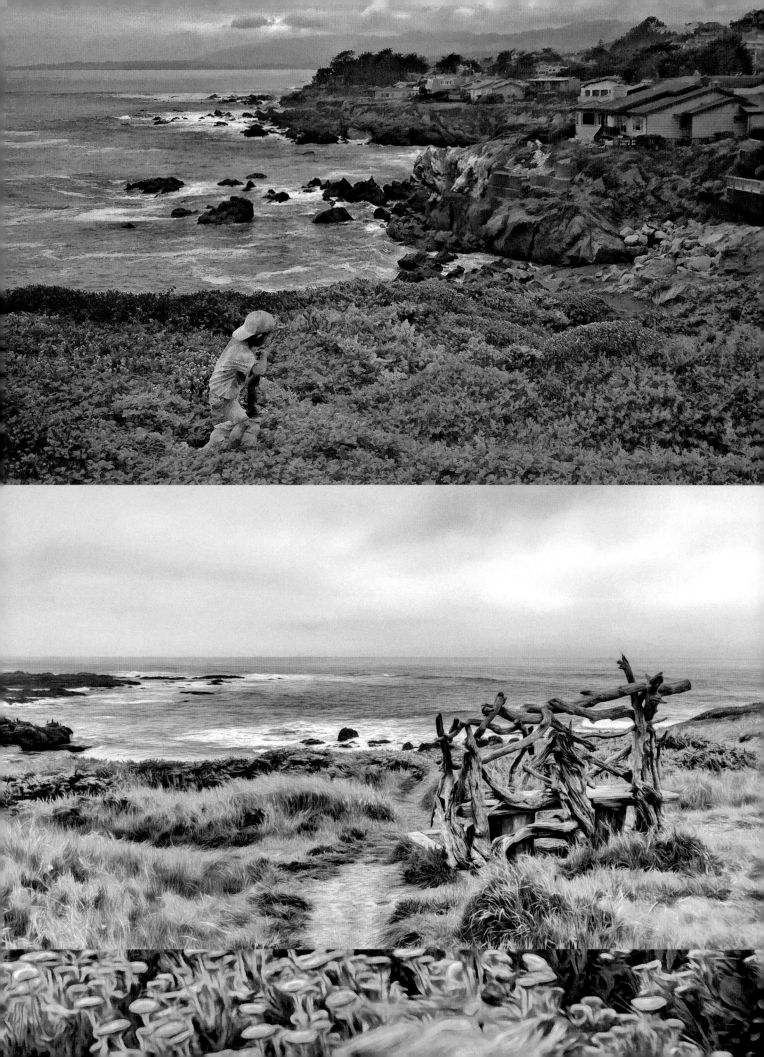

Fiscalini Ranch offers a network of trails both along the ocean and through the forest.

The preserve is dog friendly. Some trails require leashing. Others don't.

Pets love this exciting area with its abundant space, wide vistas, and many scents.

Because the area is a favorite of dog owners, it offers great opportunities for pets and their owners to socialize.

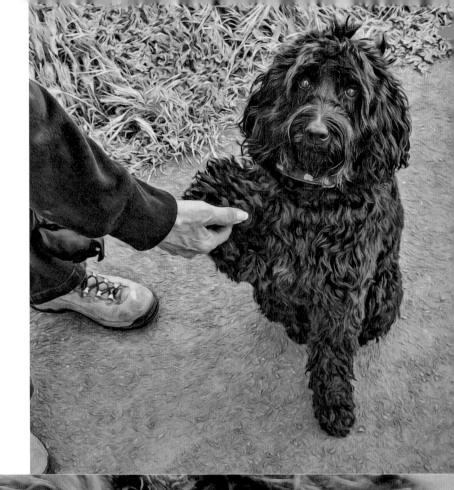

Moonstone Beach:

Moonstone Beach is the most popular promenade in Cambria. Most of the town's hotels, inns, and motels are located here.

It is a paradise for those at leisure. The view is spectacular. And there is something for everyone to enjoy.

A mile-and-a-half long boardwalk along the bluff overlooks a wide sandy beach.

Both tourists and locals stroll. Photographers take pictures. Artists paint. Beach combers search for moonstones, sea glass, and driftwood. Surfers ride the waves. Squirrels look for hand outs. Harbor seals sun themselves on the rocky outcrops. Whales sprout in the horizon, and sea birds and hummingbirds soar.

Watching the sun set over the ocean in magnificent splendor while sitting on a bench sipping a glass of wine creates a wonderful high point on a great day.

On the Fourth of July, Moonstone Beach is a prime spot from which to watch the fireworks lighted at Shamel Park.

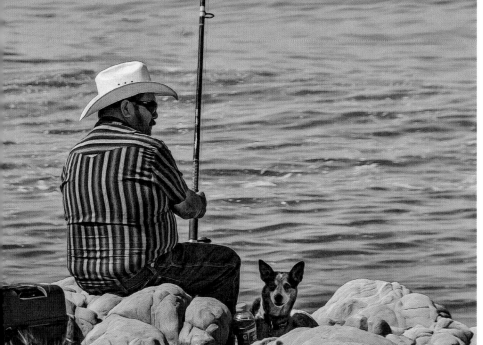

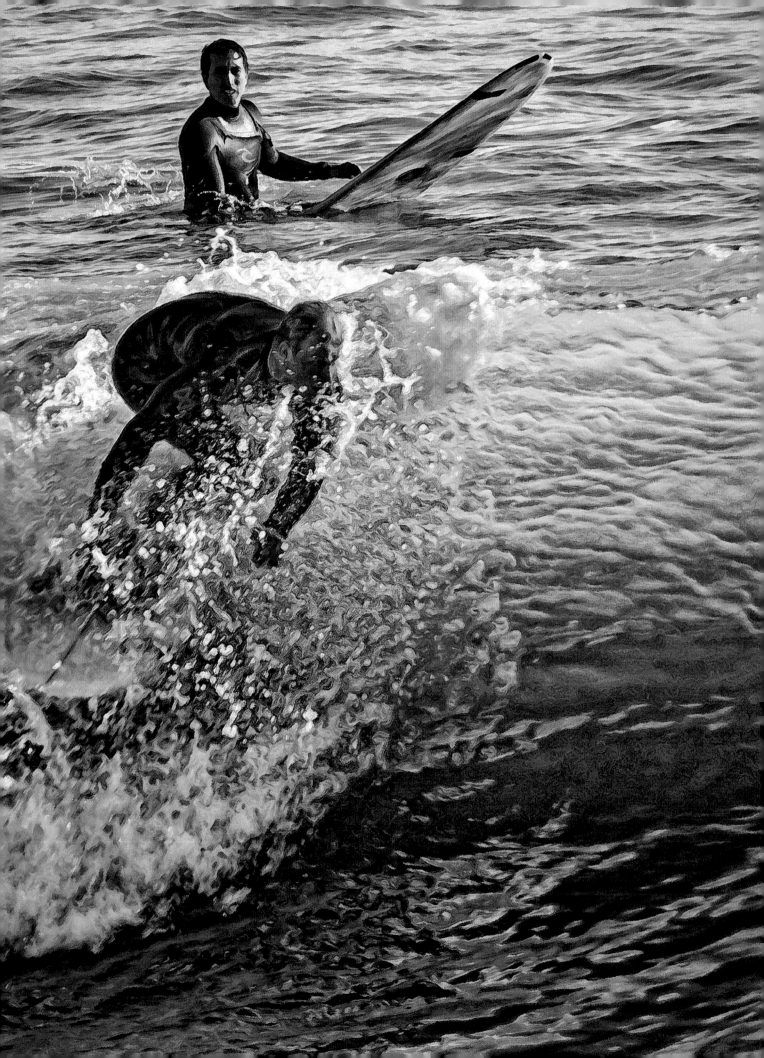

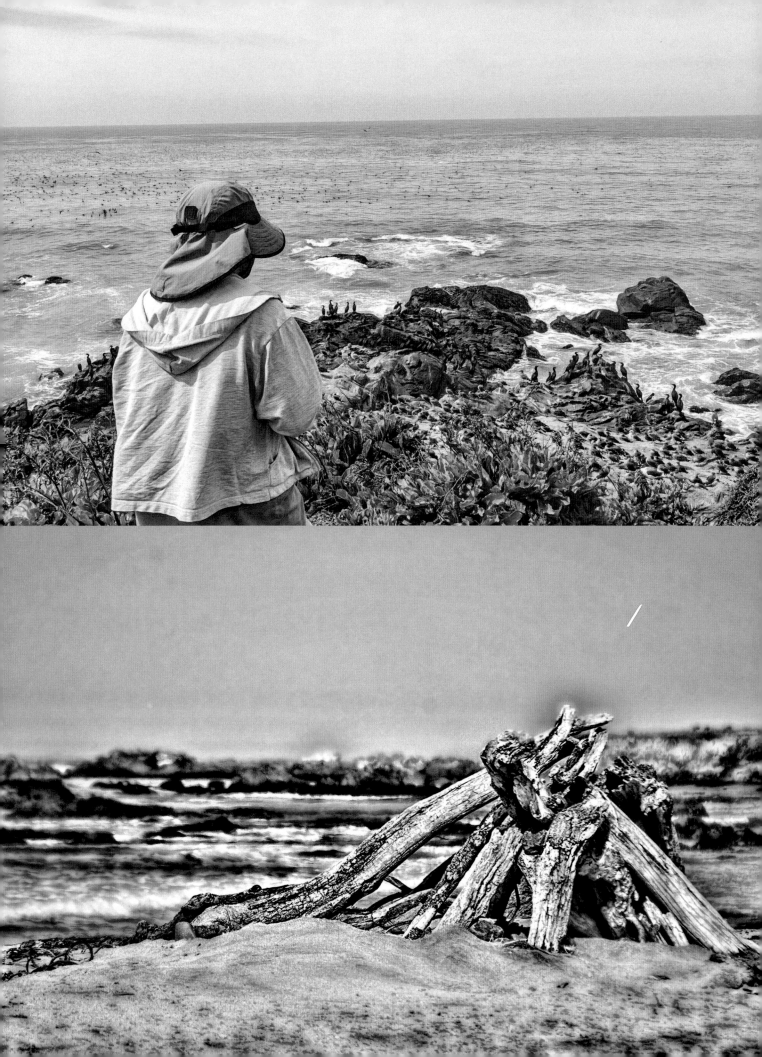

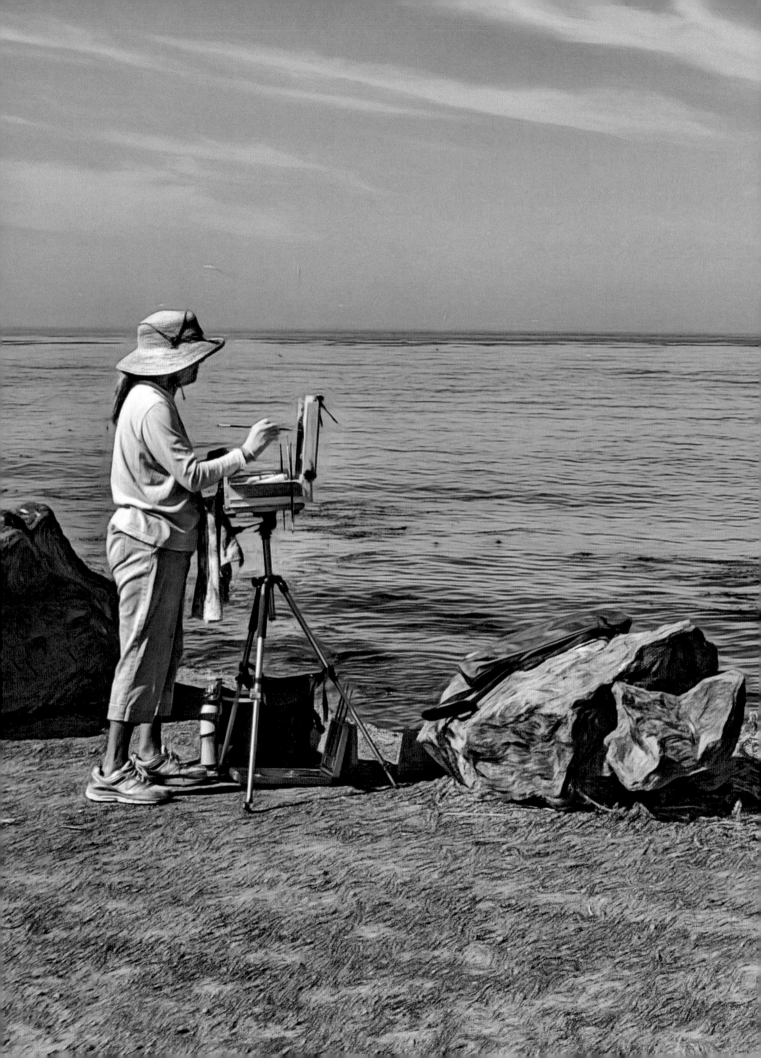

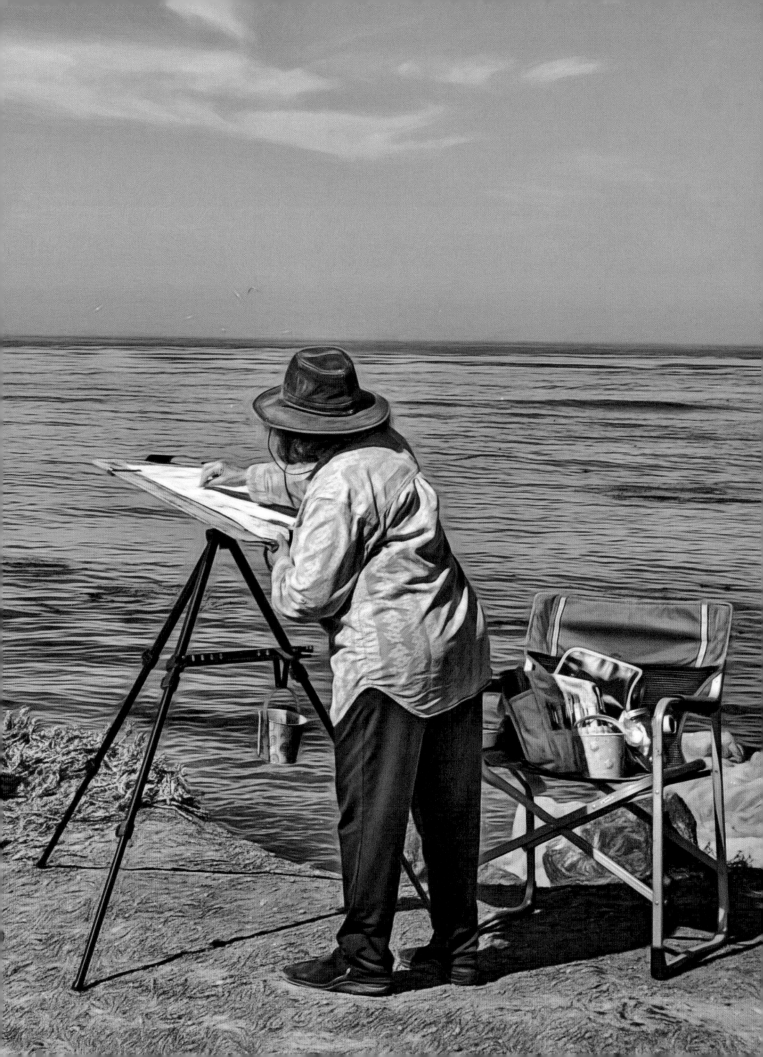

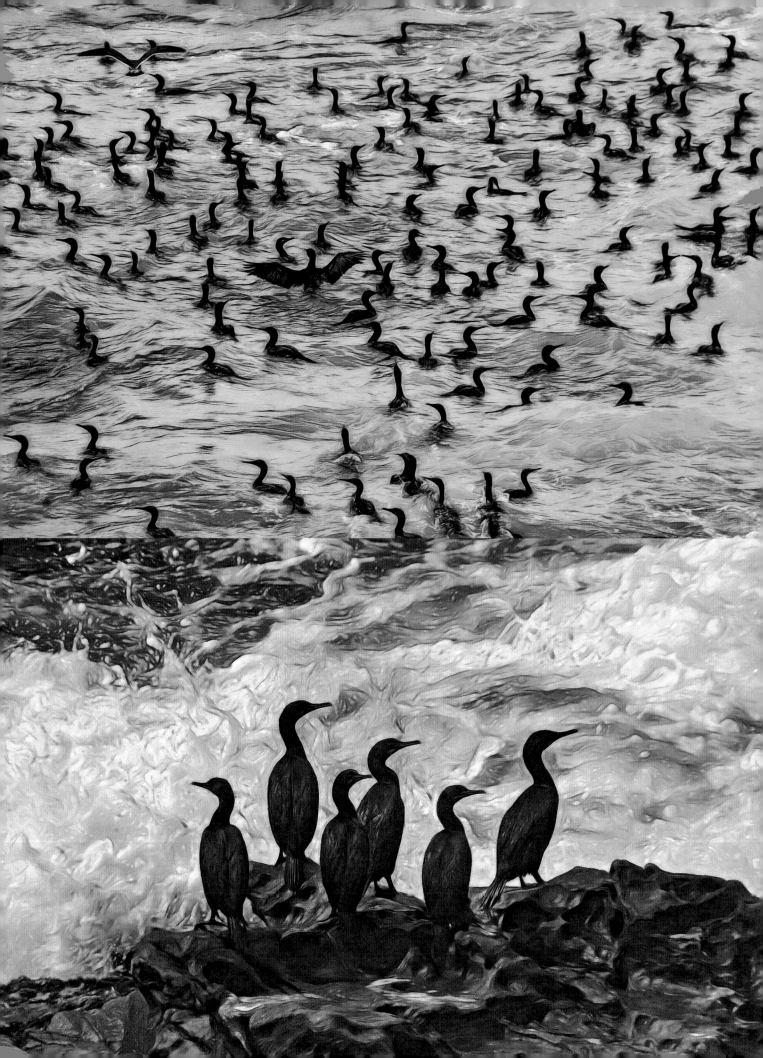

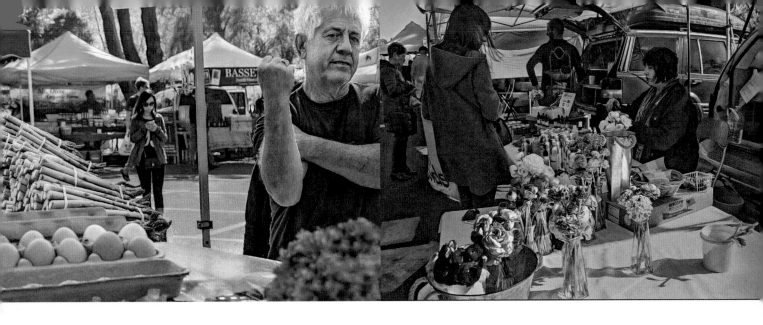

Farmers Market:

Cambria hosts a Farmer's Market every Friday afternoon on the Veteran Hall parking lot. Watching the crowd and meandering among the colorful booths is a fun thing to do. You can buy flowers and lotions as well as ready to eat barbecue and locally grown fruits and vegetables.

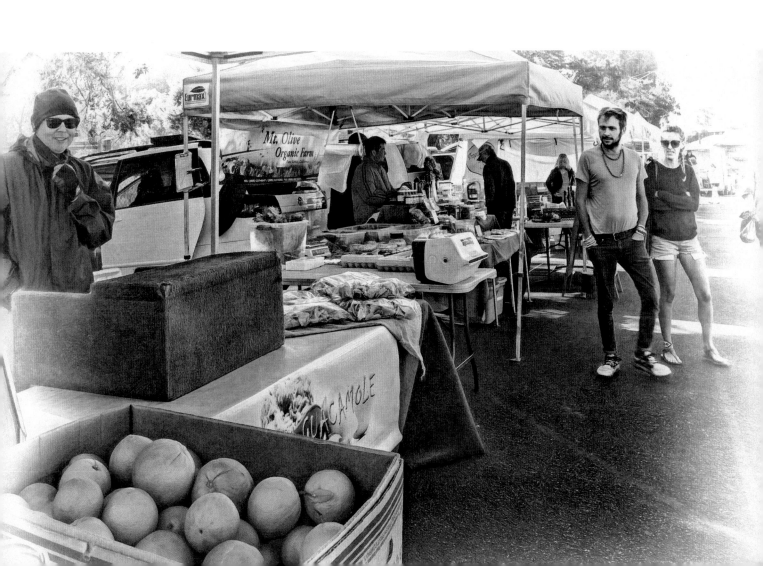

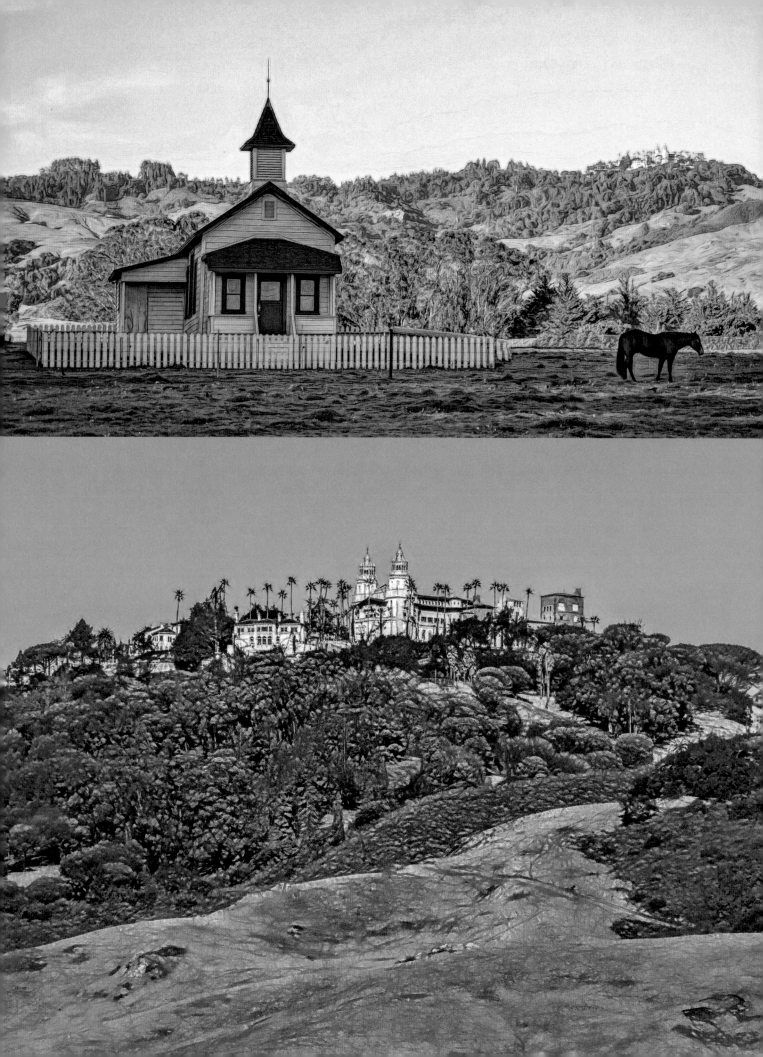

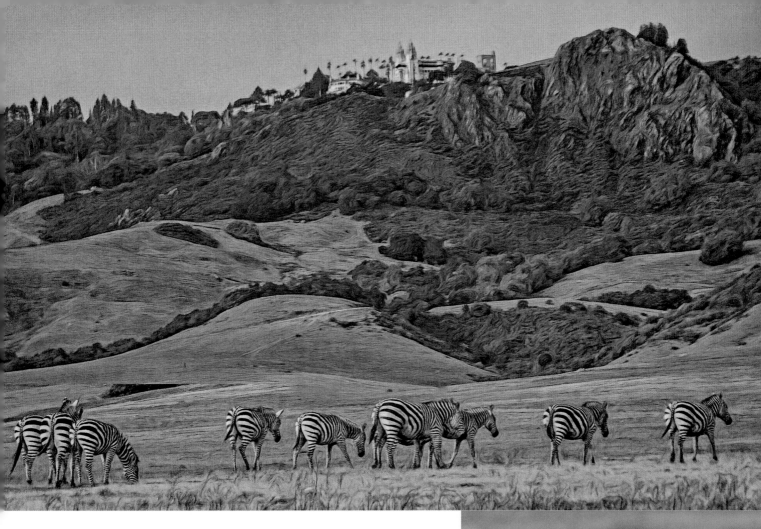

Hearst Castle San Simeon Cove and Pier:

Hearst Castle has become an icon. It is currently the only State Park in California that pays its own way. People flock to see the legendary site and all the amazing antiques on display.

They marvel at the story of how caravans of mules carried the first building materials the seven miles up rugged mountain trails.

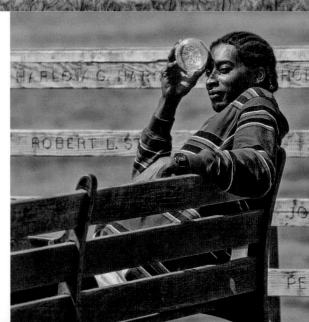

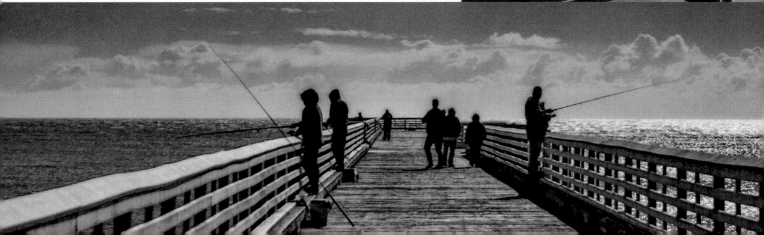

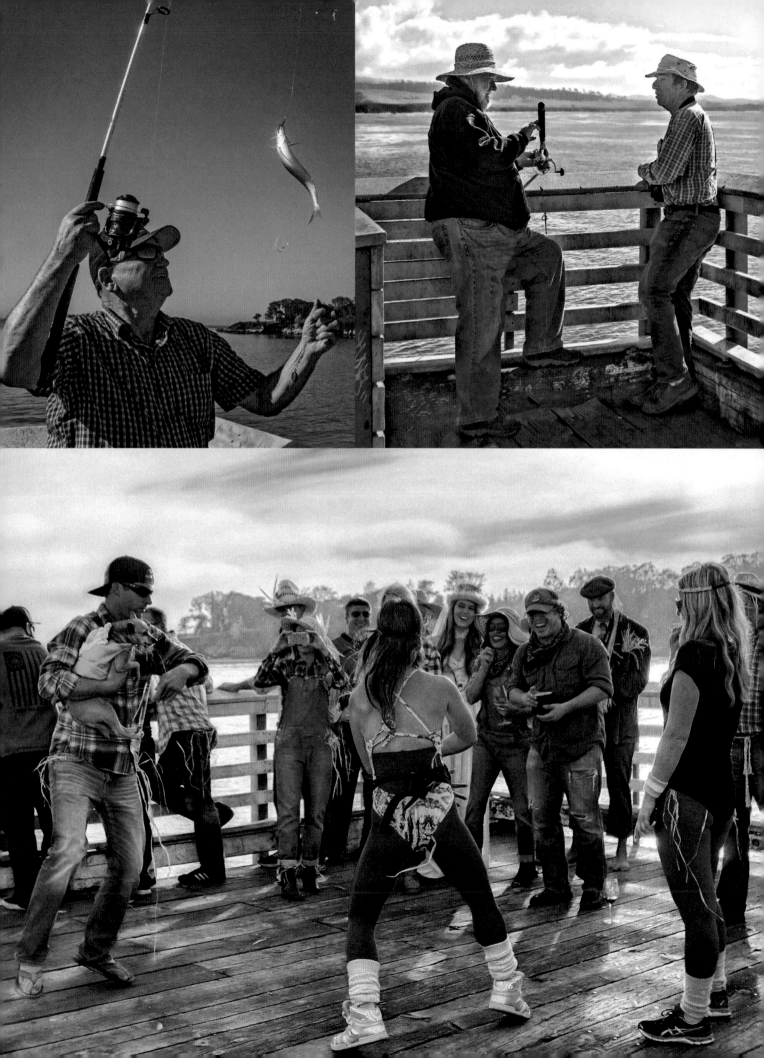

Even today, only a narrow, windy road leads to the castle. As a result, visitors must assemble at the huge, new visitors' center and continue from there by shuttle.

Nestled below Hearst Castle is the San Simeon Cove and the San Simeon Pier. Both are natural playgrounds for young and old. You can visit the discovery center, rent a kayak or paddle board, swim, hike, fish, dance, beat your drums, get married, or just relax and hang out.

A small, but picturesque, pine and eucalyptus forest lines the cove. And there are abundant picnic tables, and communal BBQs.

The old San Simeon village—-the enclave surrounding San Simeon cove—has several old buildings. They include the old school and Sebastian's Store.

The store building was moved here on skids in 1873 and served as a trading post for whalers and miners. Today, it houses wine tasting and an eatery.

The cove serves as a rest-stop for a few migrating humpback whales and their calves. The youngsters can safely learn to hunt here.

The massive kelp beds and the relatively shallow water makes the cove unattractive to sharks.

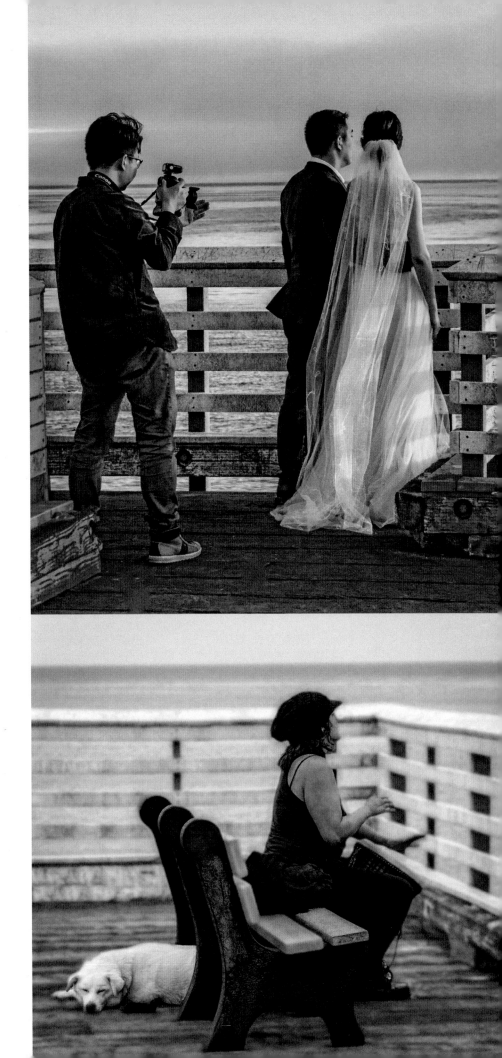

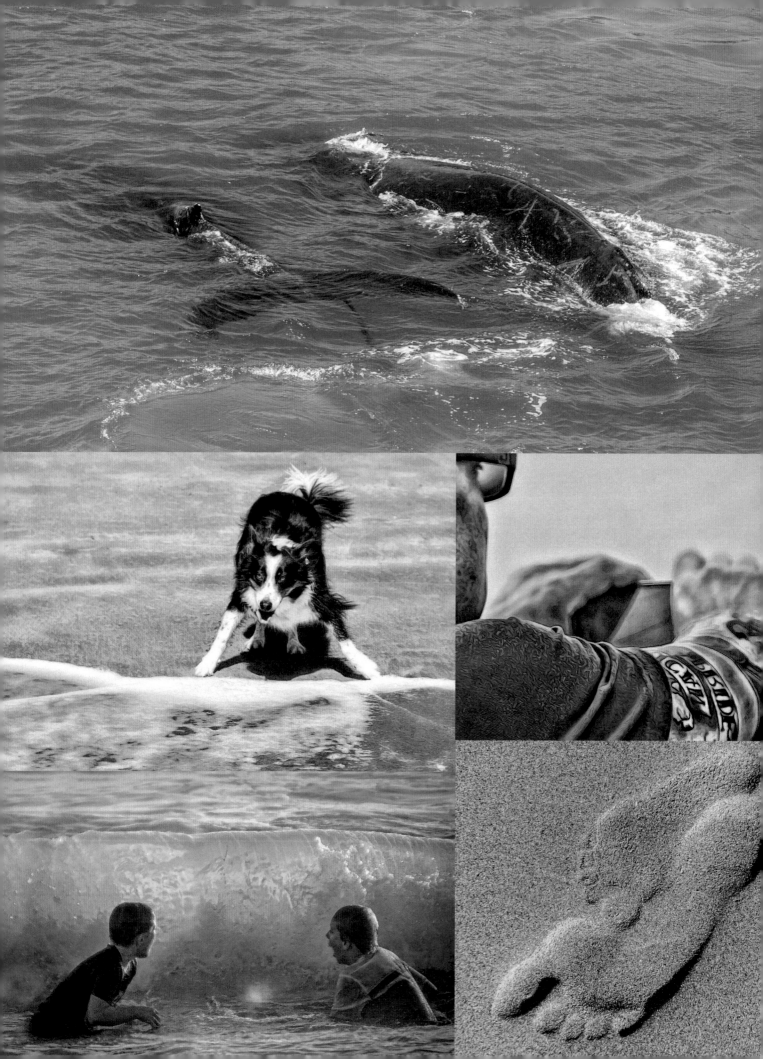

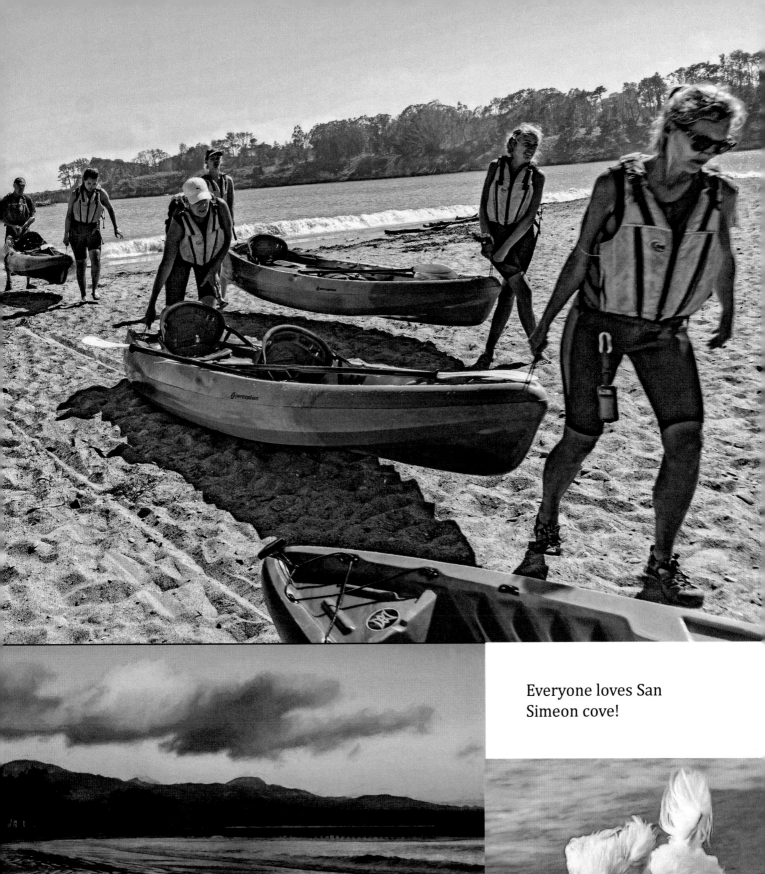

Everyone loves San Simeon cove!

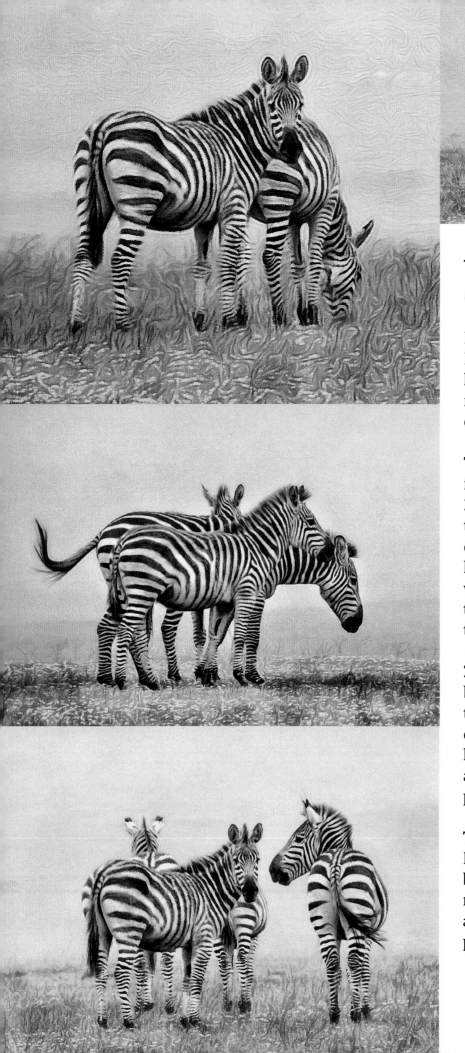
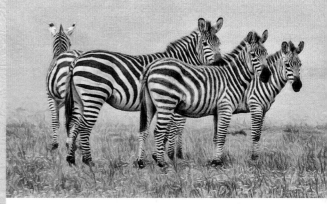

The Hearst Ranch Zebras:

It amazes people driving down Highway 1 to suddenly see large herds of zebras grazing the adjacent range land. Almost everyone stops to ooh and aah and to photograph.

These zebras are extremely fortunate. At liberty to roam the 225,000 acres of Hearst Ranch, they have as much freedom as their cohorts on the African Savannah. But here on the ranch they are fed and watered during tough times. Also, there are no predators fierce enough to concern them.

Zebras may look cute and cuddly, but it is prudent to remember that they do not have the gentle nature of horses. Zebras are cranky and have no qualms about hitting first and protecting themselves against perceived attacks.

The zebras are remnants of William Randolf Heart's zoo and their bloodlines are so strong that it is rumored that some of the offspring are exported back to nature preserves in Africa.

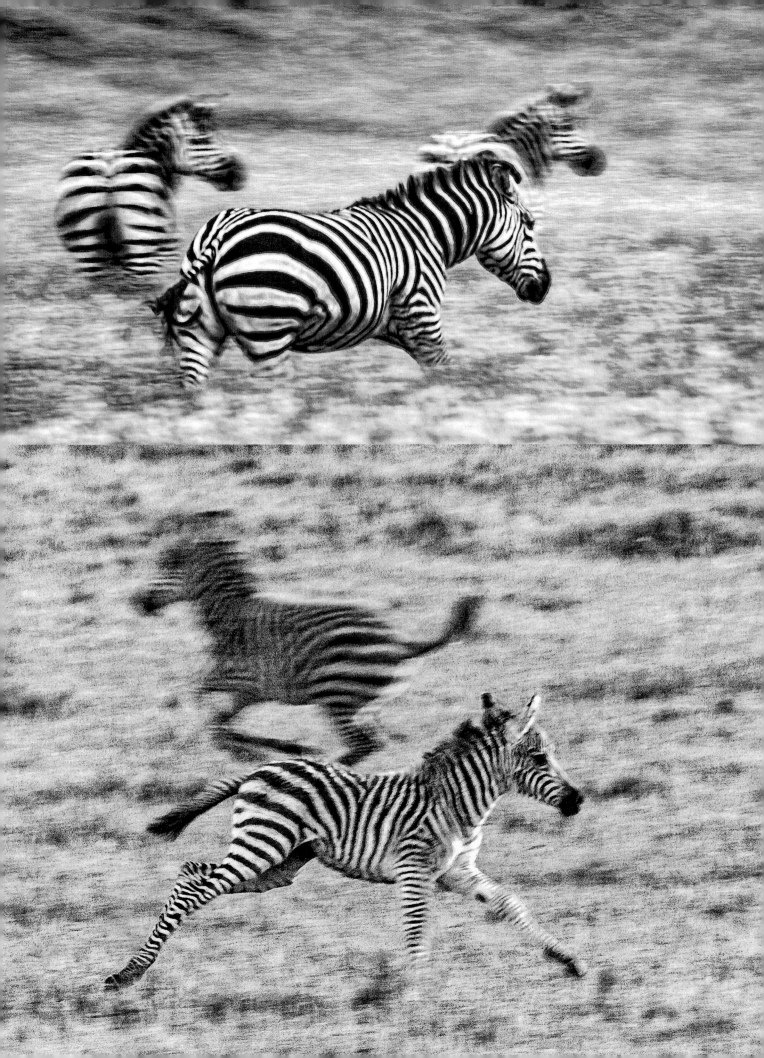

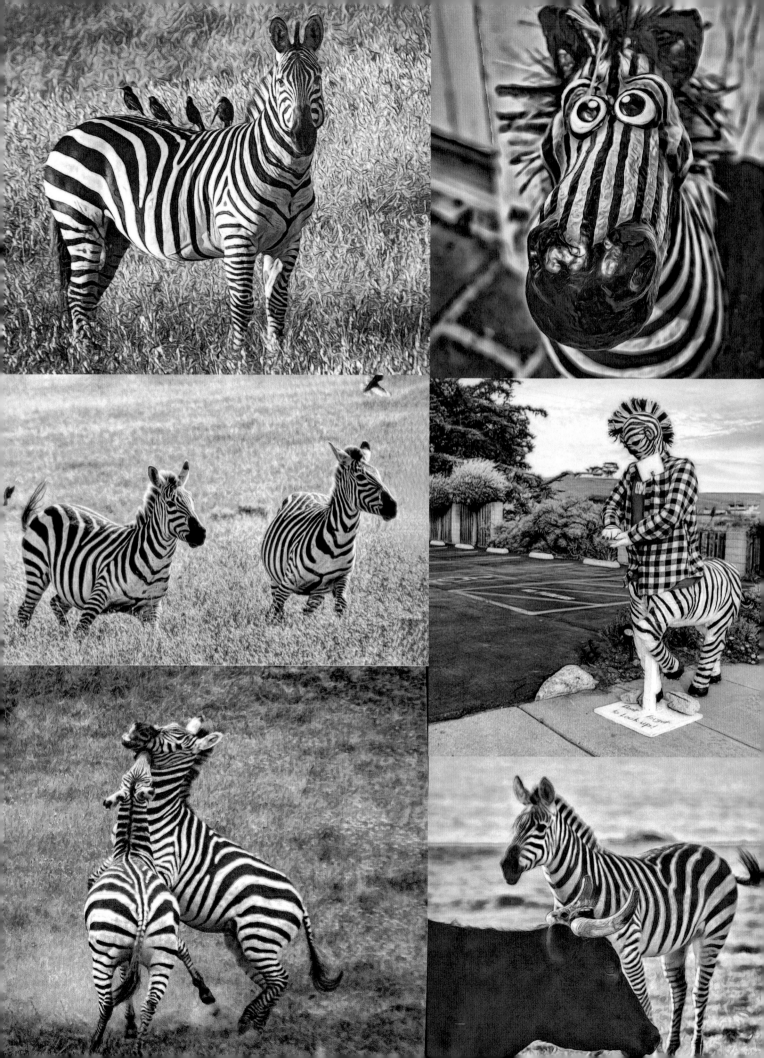

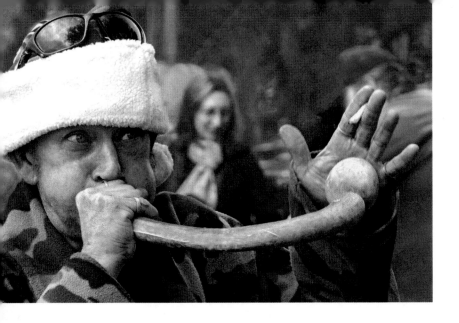

Polar Bear Dip:

January 1 Polar Dips are a tradition meant to ring in the new year with pizazz.

The most popular Polar Dip in our region takes place in Cayucos where thousands assemble each year to simultaneously plunge into the frigid Pacific.

A more intimate version of the Polar Bear Dip happens at the San Simeon Cove. Typical for Cambria it is a lighthearted, unpretentious event.

Participants and their friends share a potluck BBQ while waiting for the sound of the bugle. Immediately upon hearing it, the participants run together into the water cheered on by their less courageous spectators.

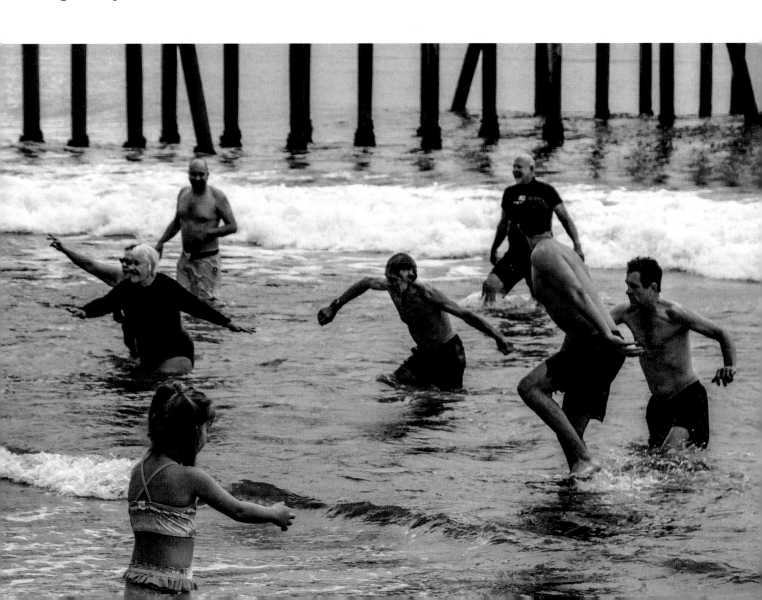

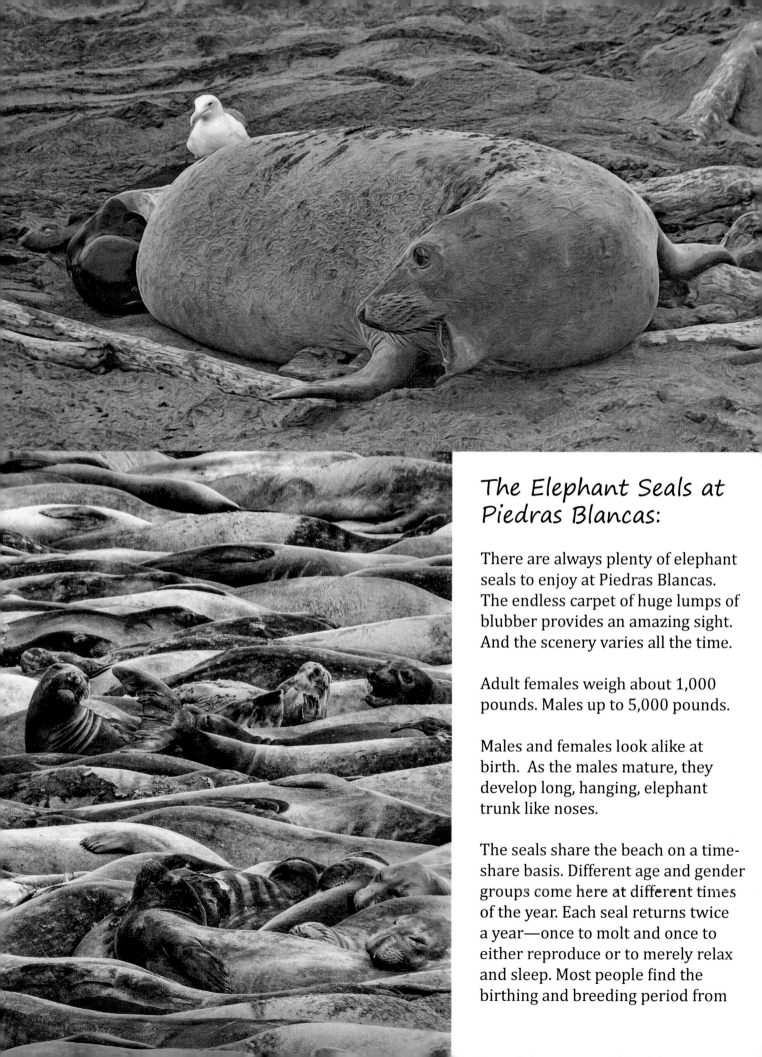

The Elephant Seals at Piedras Blancas:

There are always plenty of elephant seals to enjoy at Piedras Blancas. The endless carpet of huge lumps of blubber provides an amazing sight. And the scenery varies all the time.

Adult females weigh about 1,000 pounds. Males up to 5,000 pounds.

Males and females look alike at birth. As the males mature, they develop long, hanging, elephant trunk like noses.

The seals share the beach on a time-share basis. Different age and gender groups come here at different times of the year. Each seal returns twice a year—once to molt and once to either reproduce or to merely relax and sleep. Most people find the birthing and breeding period from

late December through February the most exciting.

Once they leave our area, the seals travel to their hunting grounds in Alaska. While hunting and on their journey they remain in the ocean 24-7.

The northern elephant seal was once believed to be hunted to extinction. Blubber seeking whalers discovered it was easier and safer to shoot down a whole beach full of dormant seals than it was to hunt whales.

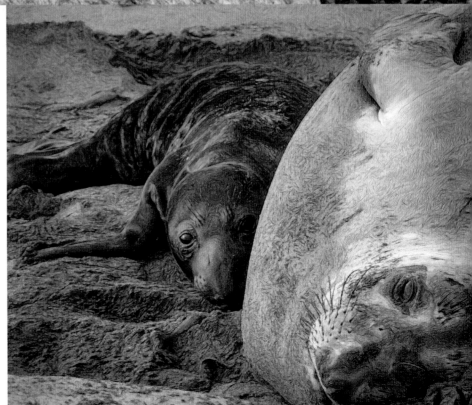

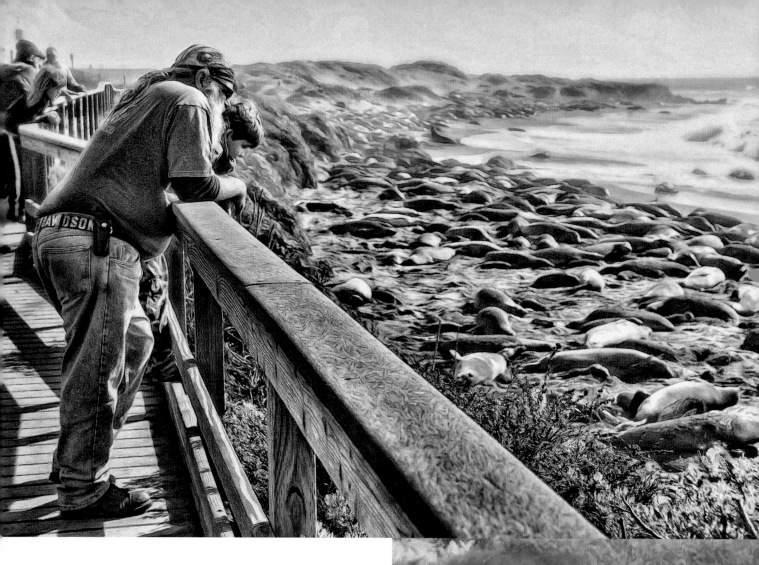

From then on, no seal was safe.

Fortunately a small colony of elephant seals was found on one of the remotest Baja Mexico islands. Once hunting elephant seals was abolished, the population multiplied rapidly.

The first 11 Piedras Blancas elephant seals arrived at the Lighthouse Beach in 1990. Now about 60,000 elephant seals visit our beaches each year.

Elephant seals hunt in deep waters, they can dive almost a mile and hold their breath for up to two hours.

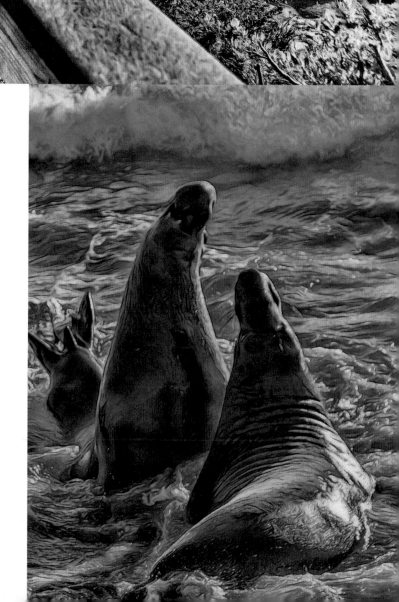

The Piedras Blancas Lighthouse:

The light station was built in 1875. Tours are offered by appointment most Tuesdays, Thursdays, and Saturdays.

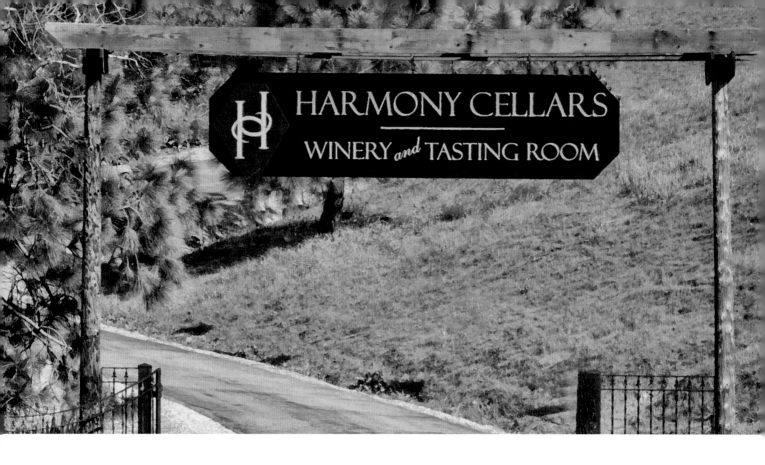

Harmony:

Be sure to include a visit to Harmony in your Cambria Stay. It is a delightful village with a low population of 18. It began its township as a dairy community. But today it boast of a glass blower, a winery, a wedding chapel, and an ice cream factory.

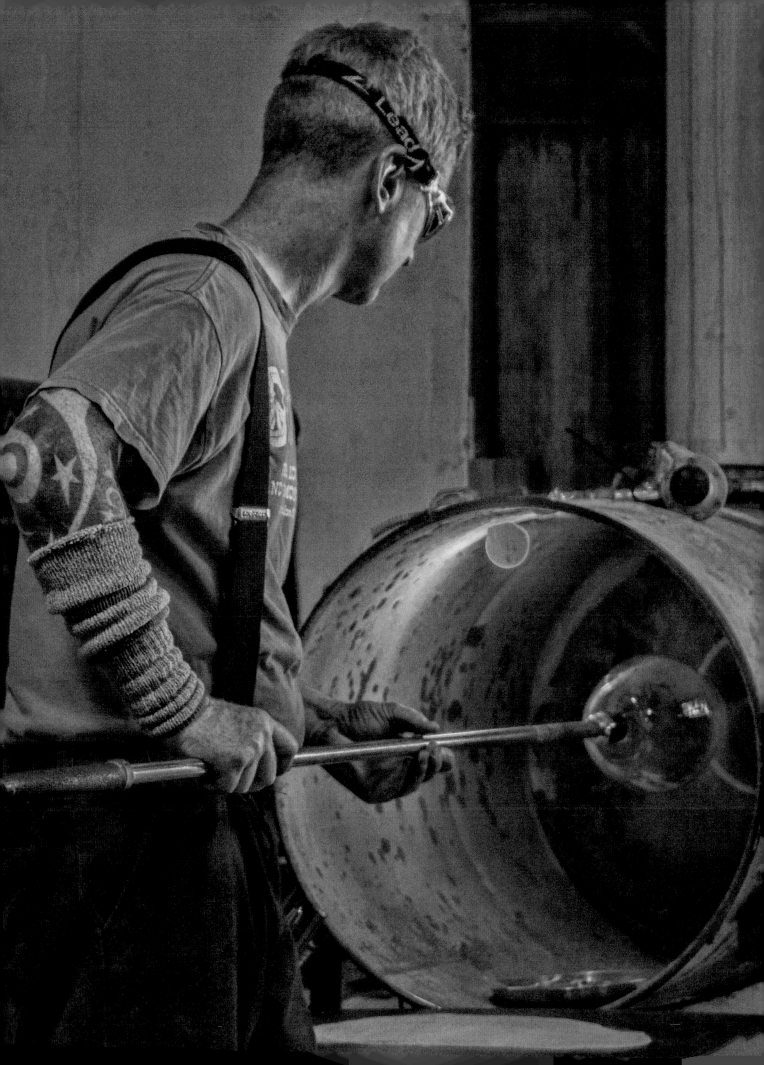

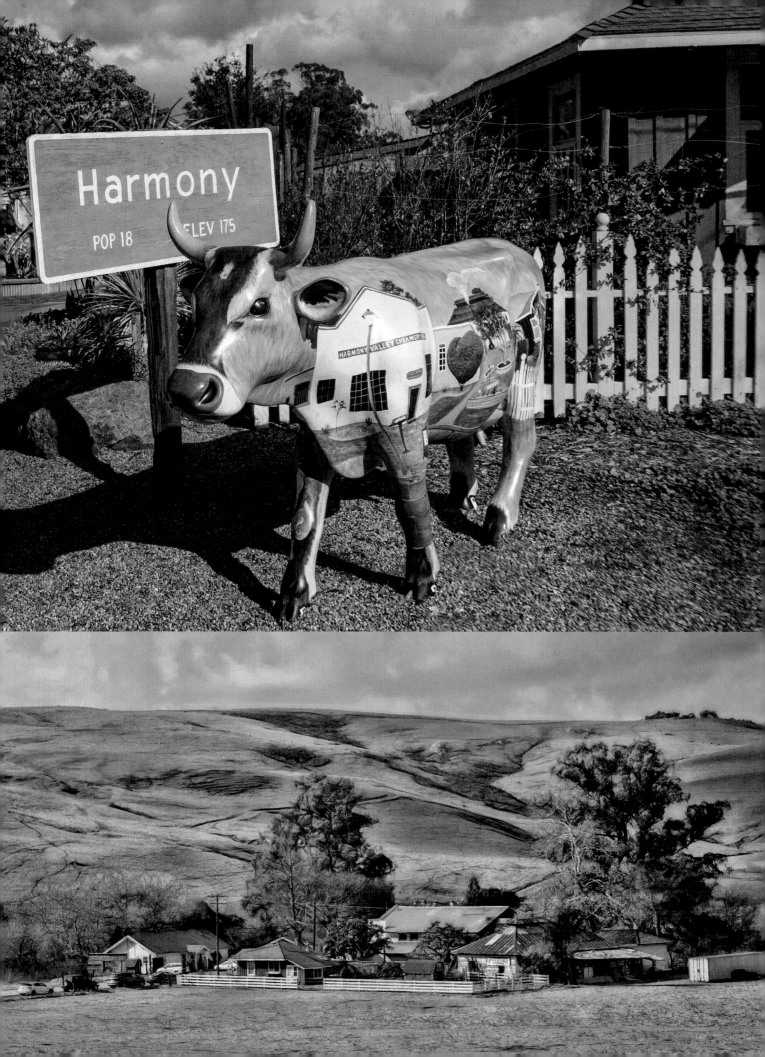

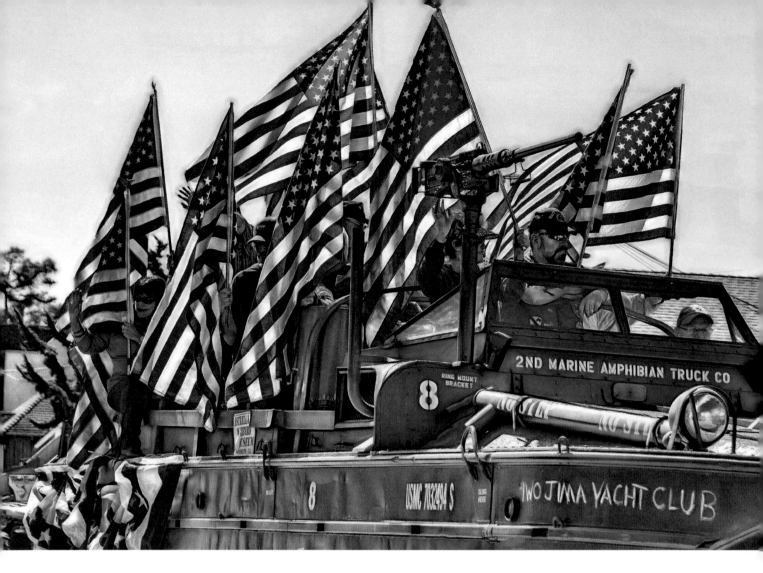

In Cambria Labor Day means Pine Dorado:

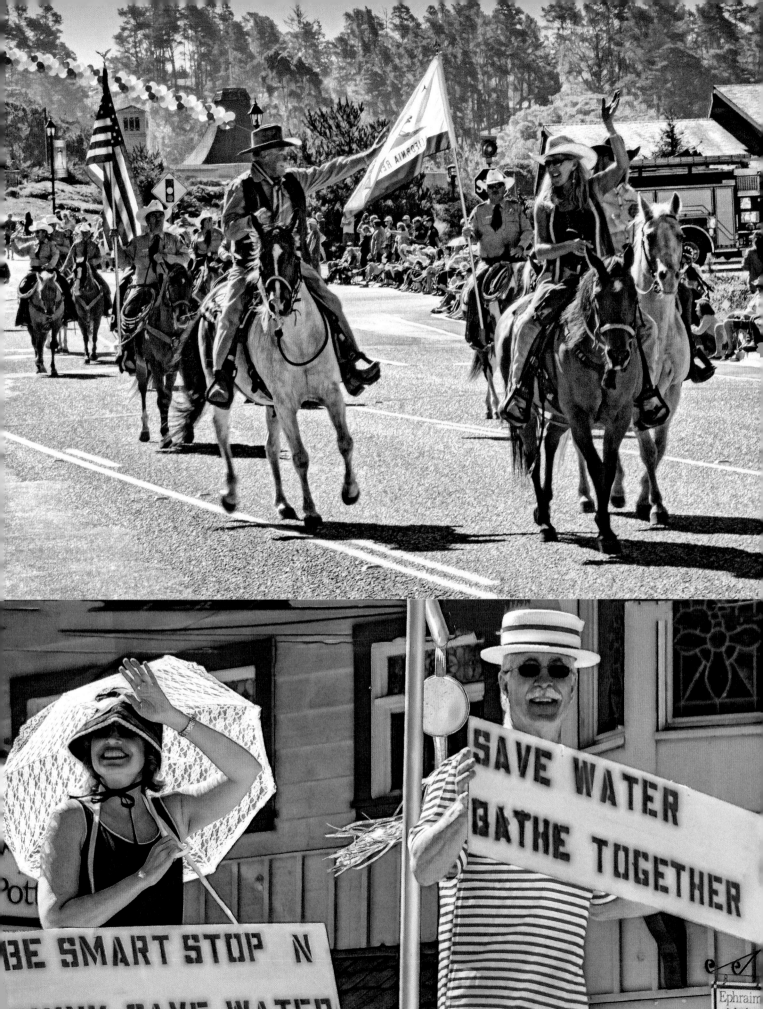

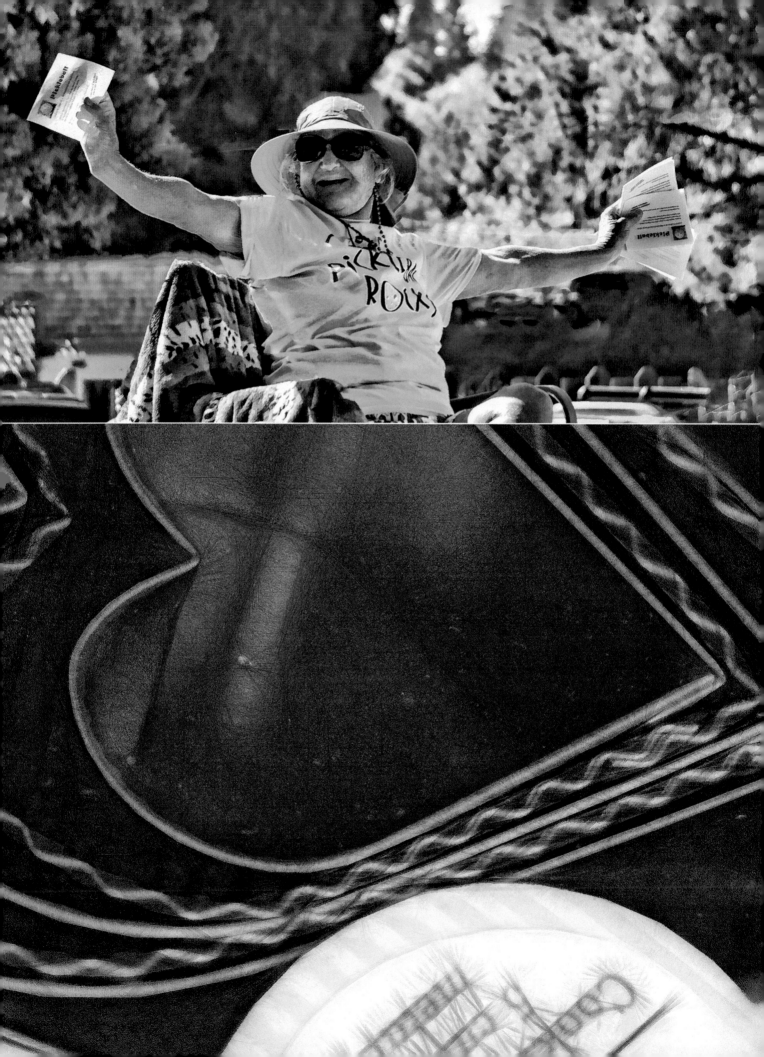

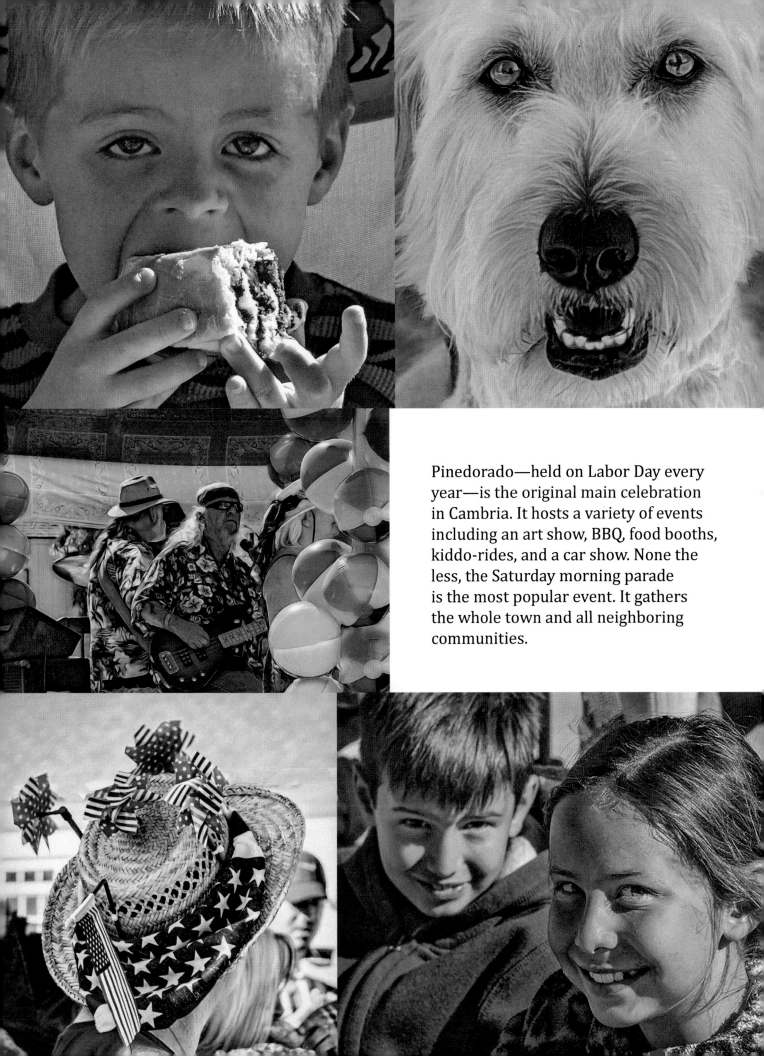

Pinedorado—held on Labor Day every year—is the original main celebration in Cambria. It hosts a variety of events including an art show, BBQ, food booths, kiddo-rides, and a car show. None the less, the Saturday morning parade is the most popular event. It gathers the whole town and all neighboring communities.

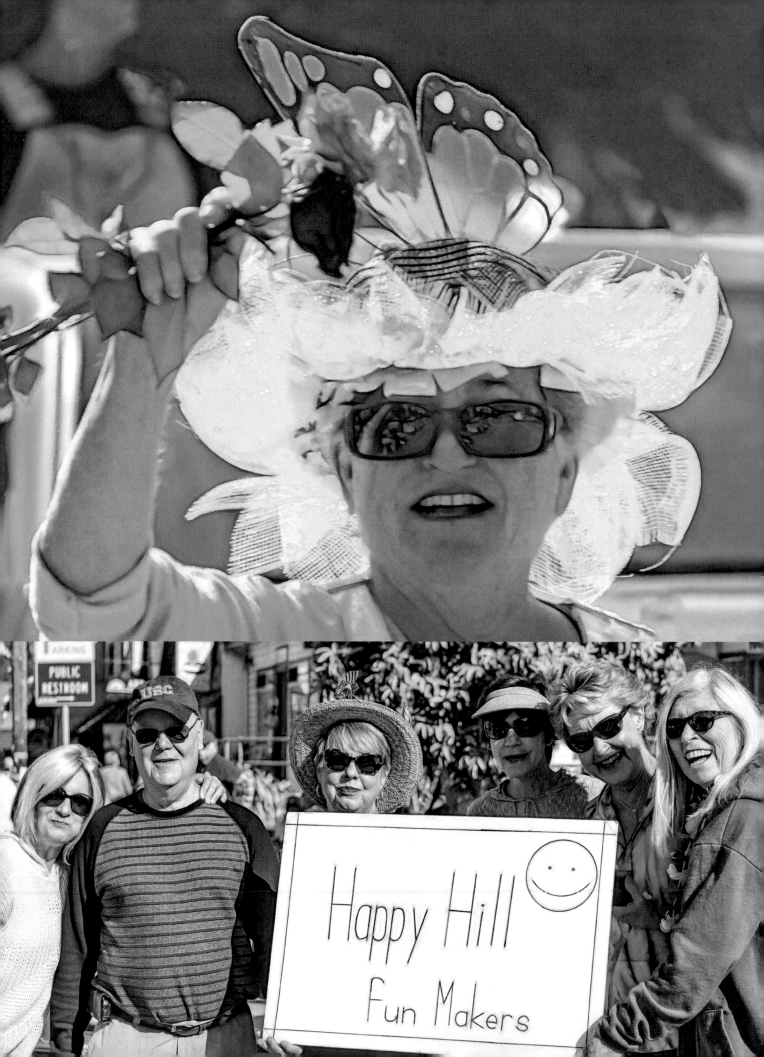

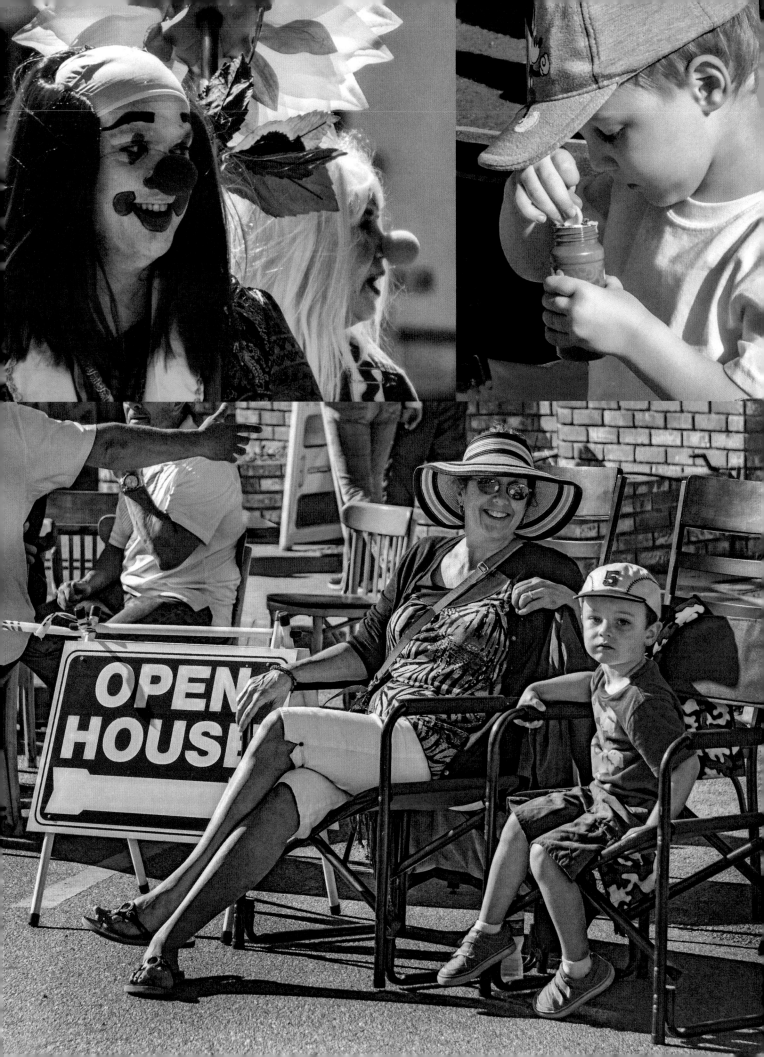

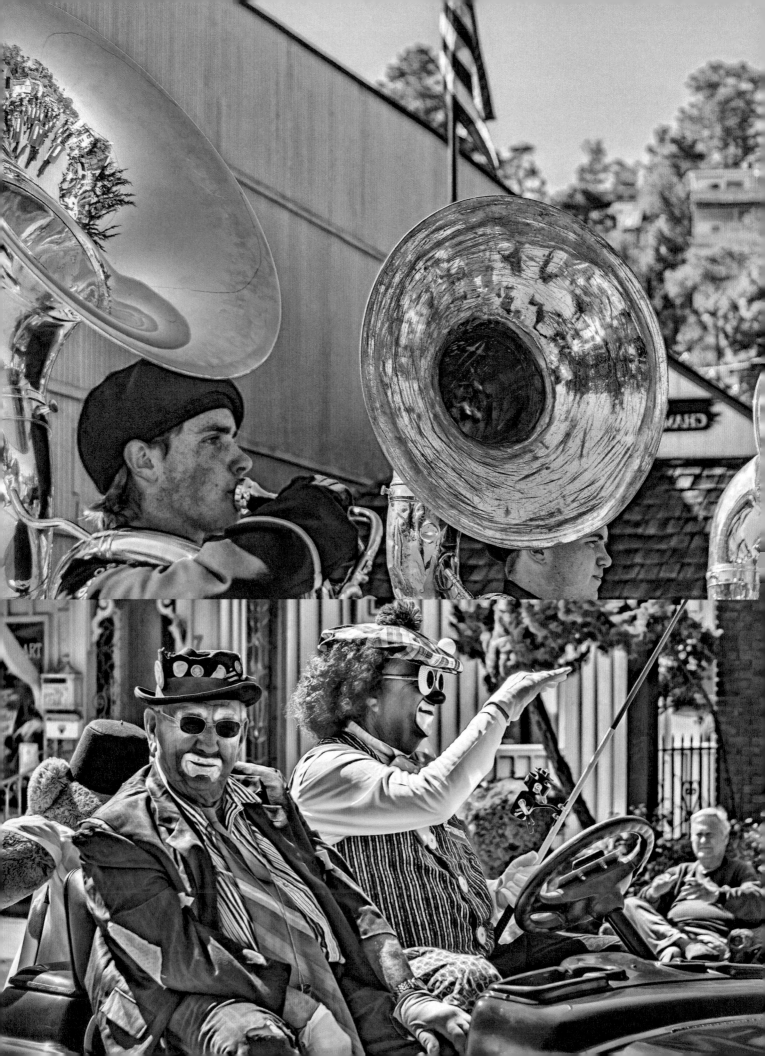

San Simeon State Park:

Located just a few miles north of Cambria on Highway 1 is The San Simeon State Park.

It consists of four different parts: beach, creek, wetlands, and forest. And it is the home of a huge popular campground with countless idyllic sites.

The campground entrance and the day use entrances are separate. Day use is free.

The water front is easily accessed from both the day and overnight parts. During the rainy season run-off from the creek forms a large lagoon on the beach that attracts thousands of gulls and other sea birds.

Be aware of poison oak as you follow the network of trails through the varied, serene landscapes of the forest. Deer and birds abound.

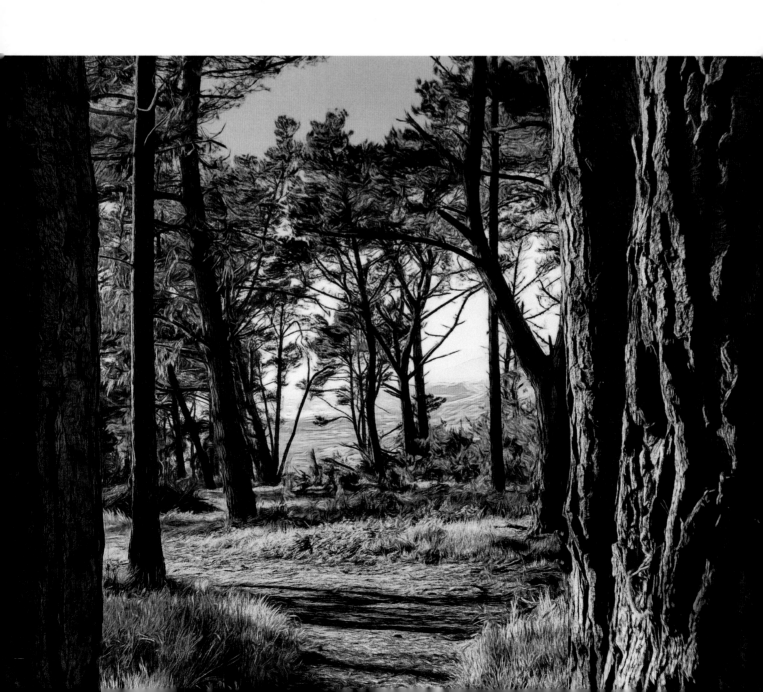

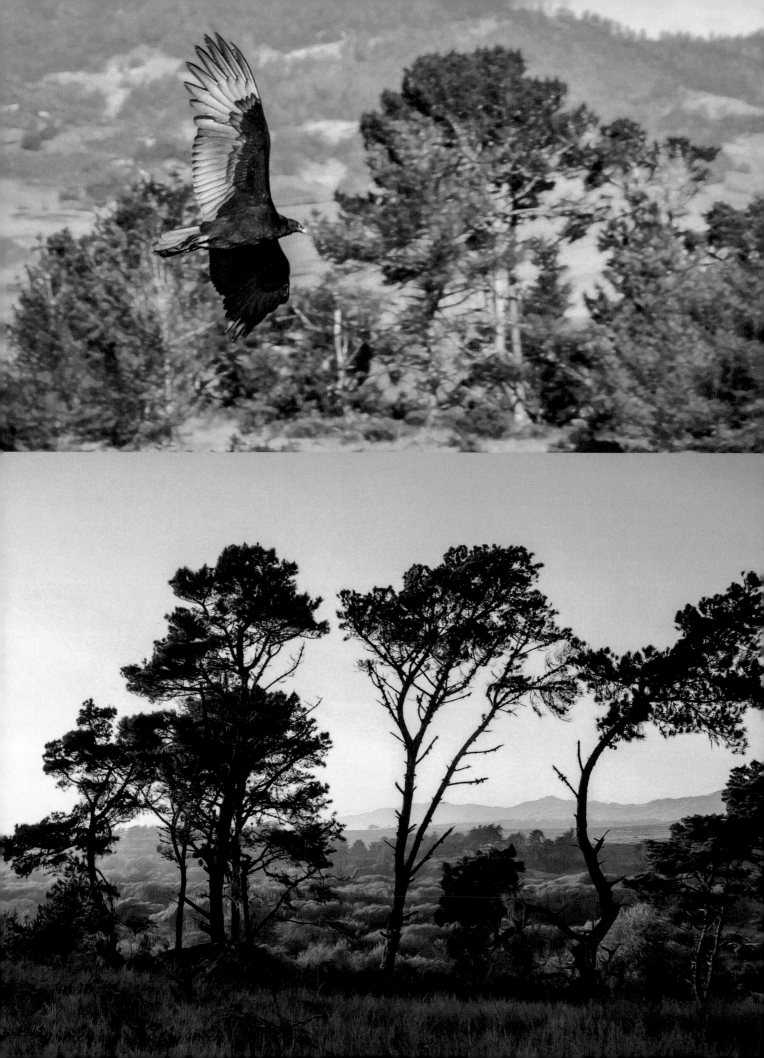

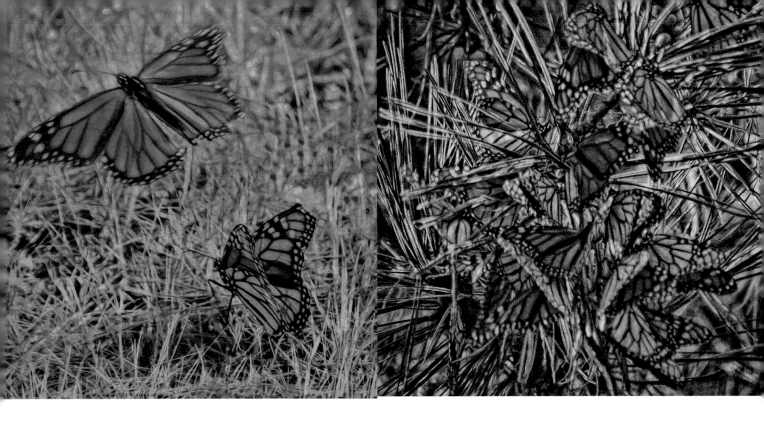

During the monarch butterfly season—late October through February—thousands of these colorful insects winter in clusters in some of the forest's trees.

If you are lucky, you may find yourself surrounded by fluttering bright orange butterflies. And then, when looking up see one cluster or more. Because the butterflies' wings are closed, the congregations blend in with the branches and look like huge bee swarms.

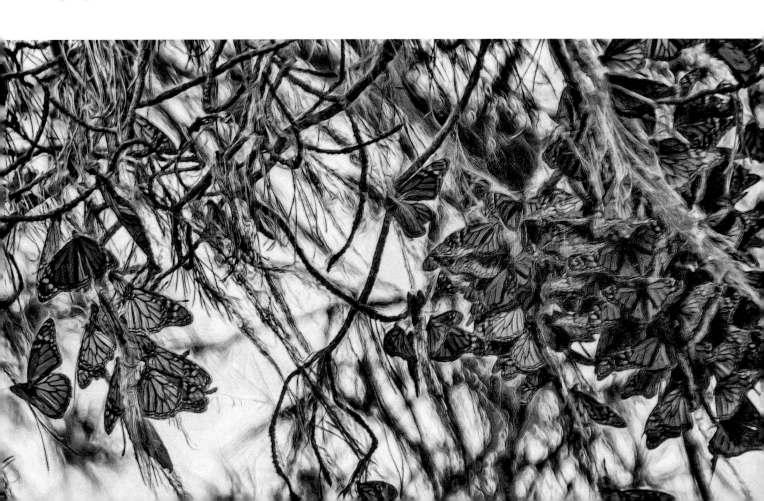

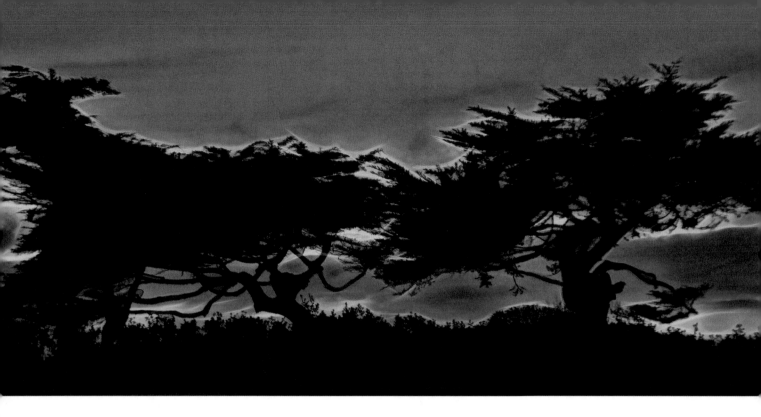

The trees in San Simeon State Park forest are relatively uncrowded. Especially at sunset, this allows you to peek through the trees at amazing views.

Look for hovering hummingbirds. They are attracted to the blooming aloe vera plants.

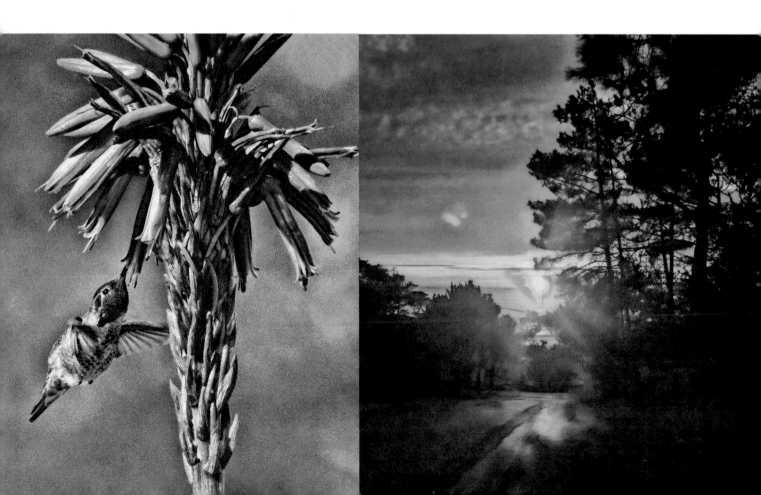

The Scarecrow Festival:

The Scarecrow Festival takes place throughout the month of October.

During that time, all of Cambria is filled with zany, artistic effigies.

Every self respecting business shows off at least one. And all compete to be more whimsical and inventive than any one else.

The statues are fun to photograph and children love them

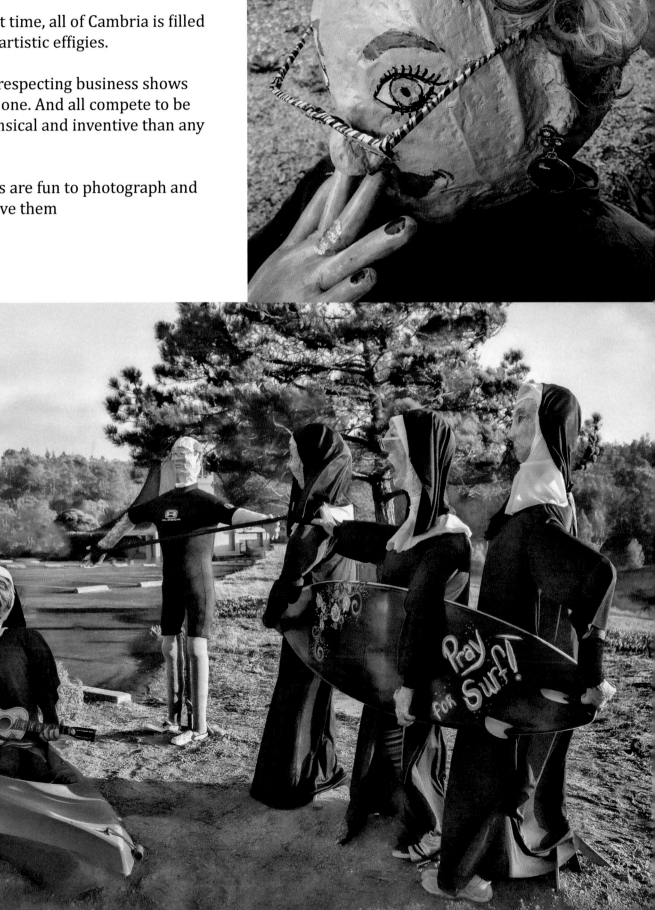

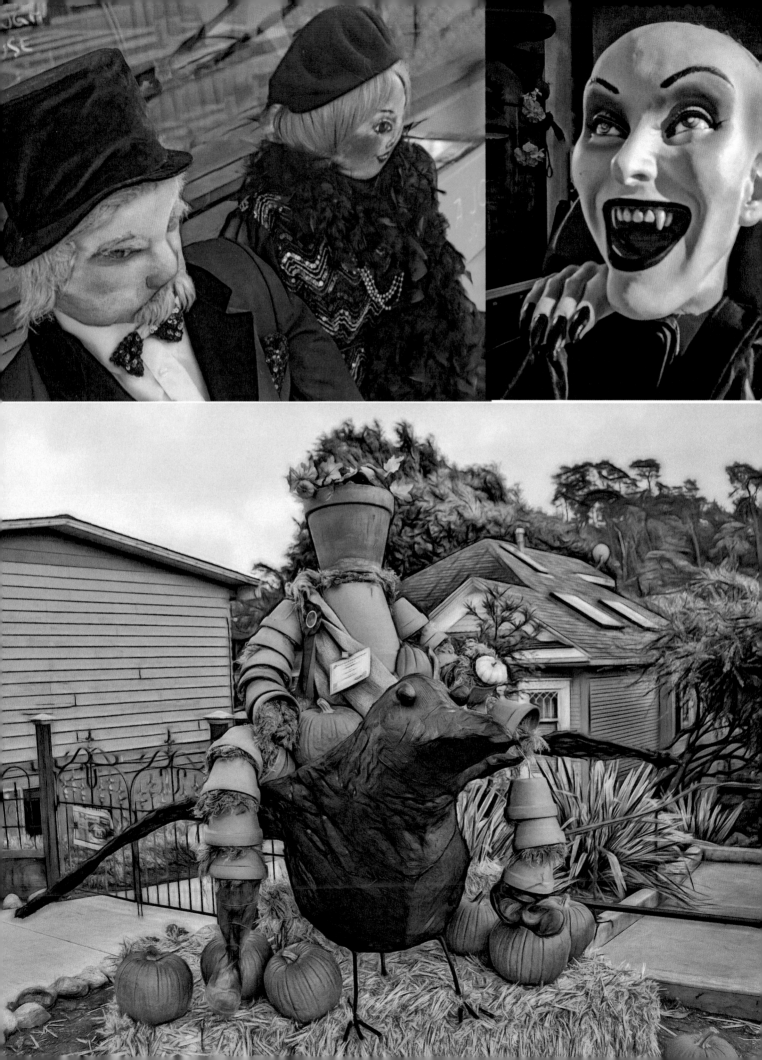

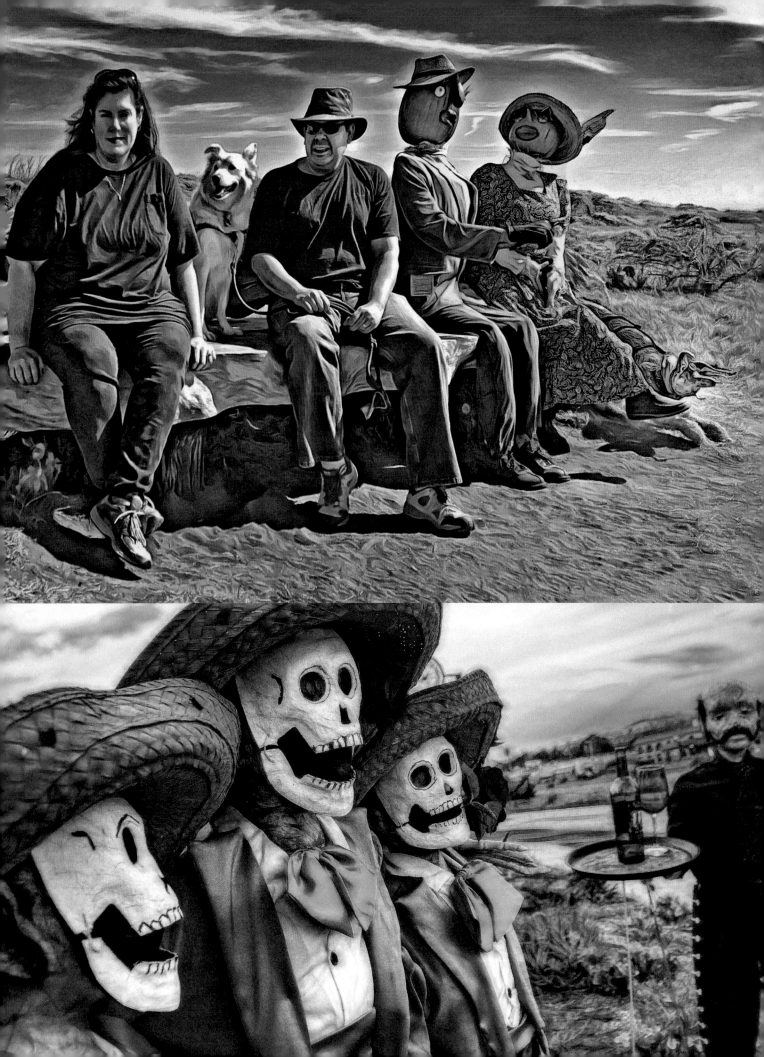

The Cambria Christmas Market:

Every year—from Thanksgiving until after Christmas—the Cambria Pines Lodge hosts an amazing Christmas market with Santa, live music, booths and more than 10 miles of colorful light strings.

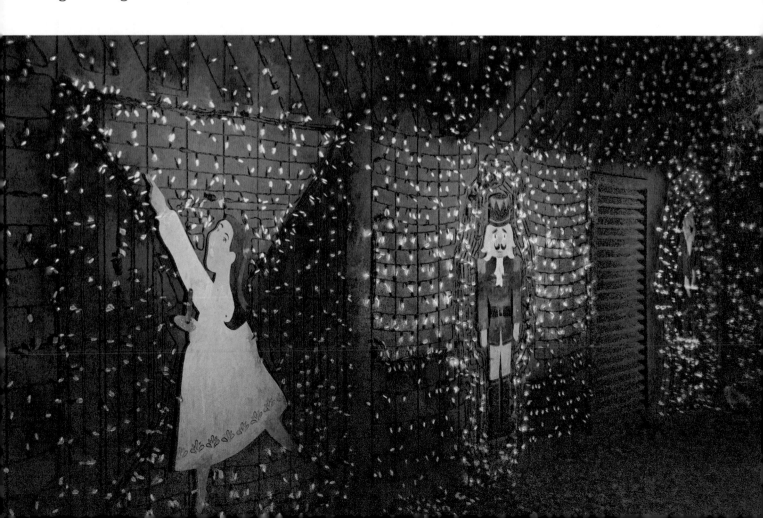

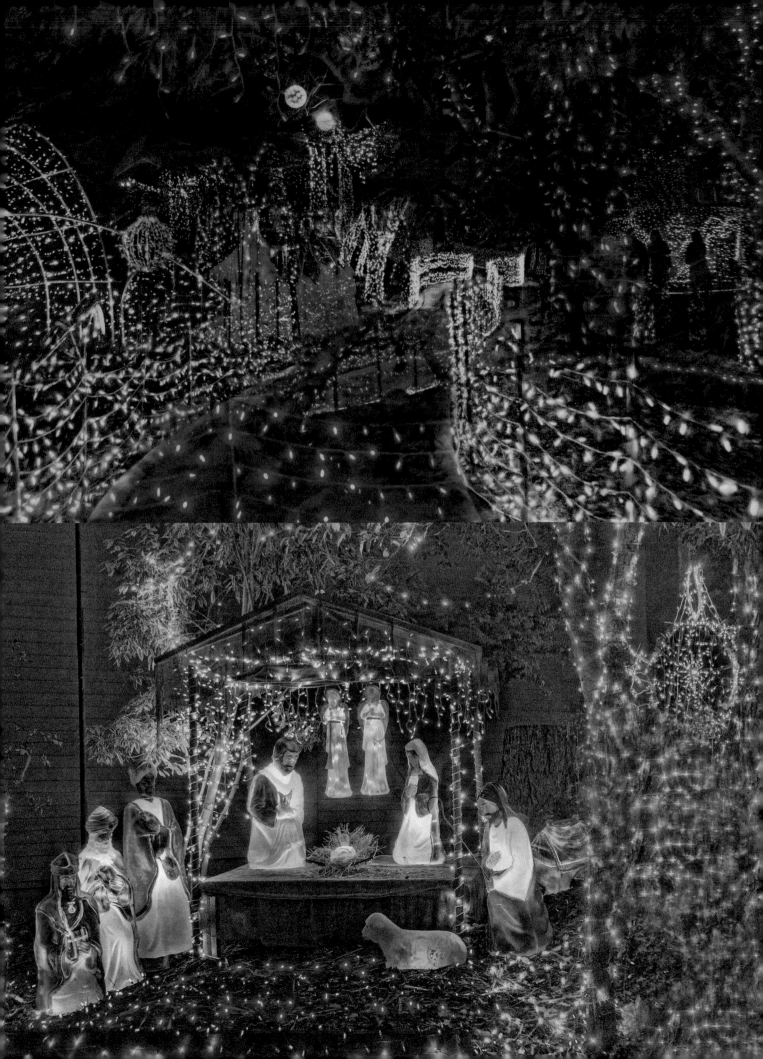

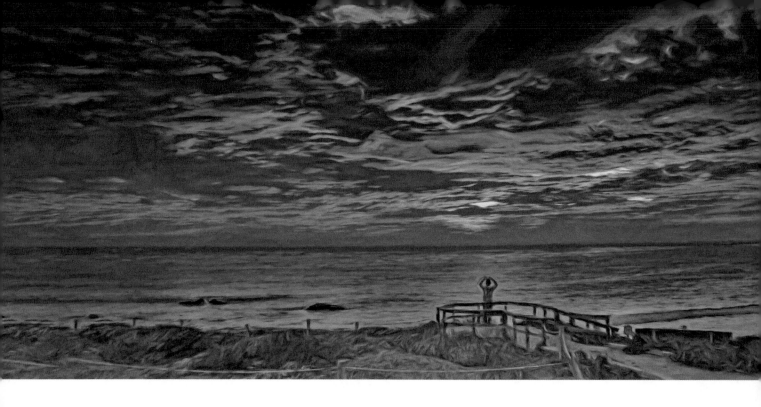

I hope you have enjoyed browsing this book as much as I have enjoyed creating it. Cambria is a wonderful place that you miss when you are away from it and that you—once you know it— will want to return again and again. Hope to see you here again, soon!

My mission in life is to share my magic moments and this book is an attempt to do so. My fine art photography as well as my text is solely meant to entertain and inform. Neither is meant to advertise or endorse.

If you would like to see more of my pictures and other books, visit my websites:
Http://EHaug.com and http://Elisabeth Haug

Meanwhile, may the force of nature be with you!

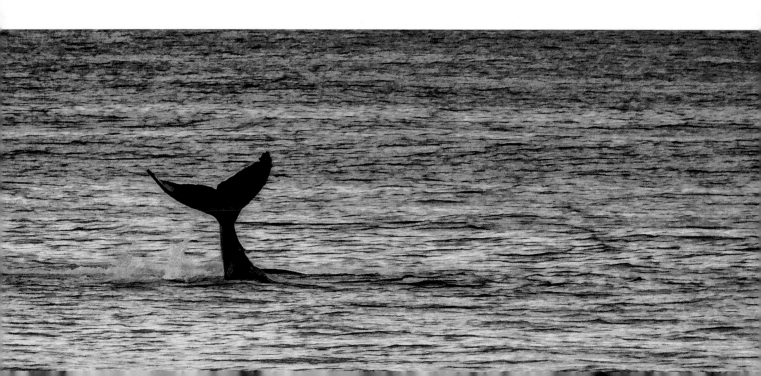

Made in the USA
Middletown, DE
22 January 2022

59379787R00044